Monuments to Heaven
Baltimore's Historic Houses of Worship

To George
Best Wishes

Sally Johnston
Lois Zanow

LOIS ZANOW AND SALLY JOHNSTON

Photographs by Denny Lynch

AuthorHouse™
1663 Liberty Drive
Bloomington, IN 47403
www.authorhouse.com
Phone: 1-800-839-8640

First published by AuthorHouse 5/9/2011

ISBN: 978-1-4520-8537-1 (sc)

Library of Congress Control Number: 2010915031

Printed in the United States of America

This book is printed on acid-free paper.

authorHOUSE®

About the front cover: First and Franklin Street Presbyterian Church
About the back cover: The interior of St. Leo the Great Roman Catholic Church

CONTENTS

INTRODUCTION

When we shared an office at the Baltimore City Life Museums, we discovered that we both had an interest in Baltimore's history. Lois came from Chicago, where she loved to give tours of Chicago's historic churches. Because there was no book available on Baltimore's religious buildings, Lois felt there was a general lack of information on the subject. Sally had been associated with many of Baltimore's history museums and loved the city's rich architecture.

Intrigued by the handsome churches dotting the landscape, we began to research Baltimore City's eighteenth and nineteenth-century houses of worship. As we drove around the city, we saw distinctive spires and domes on the horizon and wondered what buildings they represented. Calling ourselves steeplechasers as we zeroed in on these structures, we decided to write a book describing the buildings' architecture and history that would appeal to the general public.

We presented our idea to Ernest Scott, who was editor of the *Maryland Historical Magazine* at the Maryland Historical Society. His encouragement and enthusiasm bolstered our determination to write a book about the extraordinary churches and synagogues in Baltimore. We were further encouraged by the reception from pastors, administrators, and church docents who were willing and proud to show us their sites. They also generously shared church brochures, books, and visitor pamphlets for self-guided tours - information unavailable elsewhere. Important contributors to our research were the Baltimore Architecture Foundation, the Enoch Pratt Library, and Deb Weiner of the Jewish Museum of Maryland. Special thanks to Bob Brugger of the Johns Hopkins Press for his guidance and support.

After compiling a list of over fifty churches and synagogues over one hundred years old, we arranged to tour the buildings. During our visits we discovered that outstanding architects had designed the buildings and that the best artisans of the day had been engaged in the interior design. Within these houses of worship are outstanding examples of windows, statuaries, paintings, mosaics, carvings, and religious artifacts. Robert Cary Long and his son Robert Cary Long Jr., Benjamin LaTrobe, and Stanford White are a few of the architects, and Louis Comfort Tiffany, John LaFarge, Constantine Brumidi, and Hans Schuler represent some of the artisans employed. A majority of the buildings are National Historic Landmarks or are on the National Register of Historic Places.

Churches parallel the development of the city. Our book explains why each church or synagogue was founded, the particular ethnic or social group it served, and how it has adapted over the years to Baltimore's changing demographics. We have learned that each building has

a special story to tell. These buildings are city treasures in terms of their history, architecture, and artisans' contributions to the interiors; we hope to call attention to the importance of their continuing preservation.

An important part of the buildings for us is the history connected to their origins. In addition to being distinctive landmarks, they are important centers for the neighborhood. Initially, many of these religious buildings served a bourgeoning immigrant population, particularly Irish, German, Italian, and Jewish. Some of the churches, such as St. Michael's in Fells Point, are now serving new immigrant populations. Many buildings changed congregations and denominations as the populations shifted. A few were built as memorials, such as Corpus Christi and Brown Memorial. Famous historical figures are associated with some sites, such as the Duchess of Windsor at Emmanuel Episcopal, Francis Asbury at Old Otterbein, and Daniel Coker at Bethel AME. Some churches are connected with American saints, such as Saint John Neuman at St. Alphonsus and Mother Elizabeth Seton at St. Mary's Chapel.

We concentrated on downtown Baltimore and included religious buildings in a variety of neighborhoods including Mt. Vernon, Fells Point, Historic Jonestown, Bolton Hill, and Little Italy. A wide range of religions are represented. We wished to present a succinct history with photographs of the exteriors and interiors with special focus on significant elements and treasured items. The book can be used as a guide to explore these Baltimore treasures.

The majority of the buildings are from the nineteenth century and manifest a range of popular architectural styles of the time—baroque, neoclassical, Romanesque, Victorian Gothic, Byzantine, and Greek revival. We selected only those buildings whose exterior and interior architectural integrity had not been compromised despite their age. Most of these buildings have been carefully preserved and maintained over the years by dedicated congregations, despite changing neighborhoods around them.

This has been a rewarding and exciting adventure for us. As we visited and researched each site, we were struck by the significance of the history and the magnificence of their interiors, whether simple or elaborate. While there are many structures worthy of inclusion, we decided to narrow it down to our twenty-three personal favorites. We are also including only those religious structures that still have active congregations or are used for religious ceremonies. We hope this book will contribute to the general knowledge of Baltimore's past. Perhaps the book will even inspire some readers to explore, on their own, these and other houses of worship.

Lois Zanow and Sally Johnston

❶ **Berea Temple of the Seventh Day Adventists**
1901 MADISON AVENUE

❸ **Brown Memorial Presbyterian Church**
1316 PARK AVENUE

❷ **Bethel African Methodist Episcopal Church**
1300 DRUID HILL AVENUE

❹ **Corpus Christi-Jenkins Memorial Church**
110 W. LAFAYETTE STREET

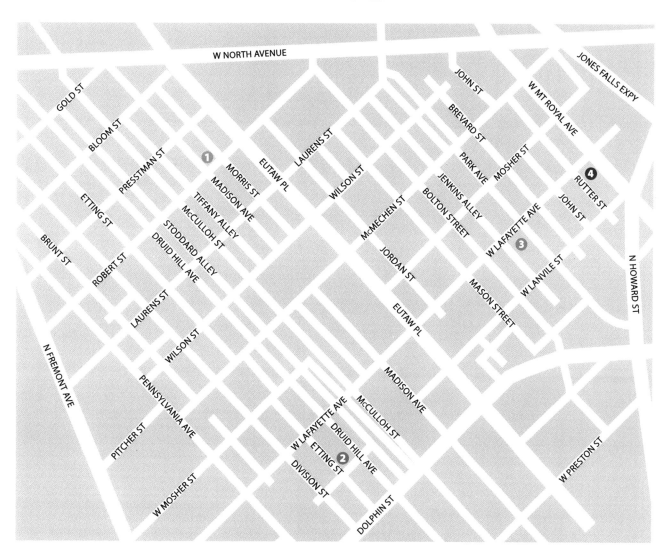

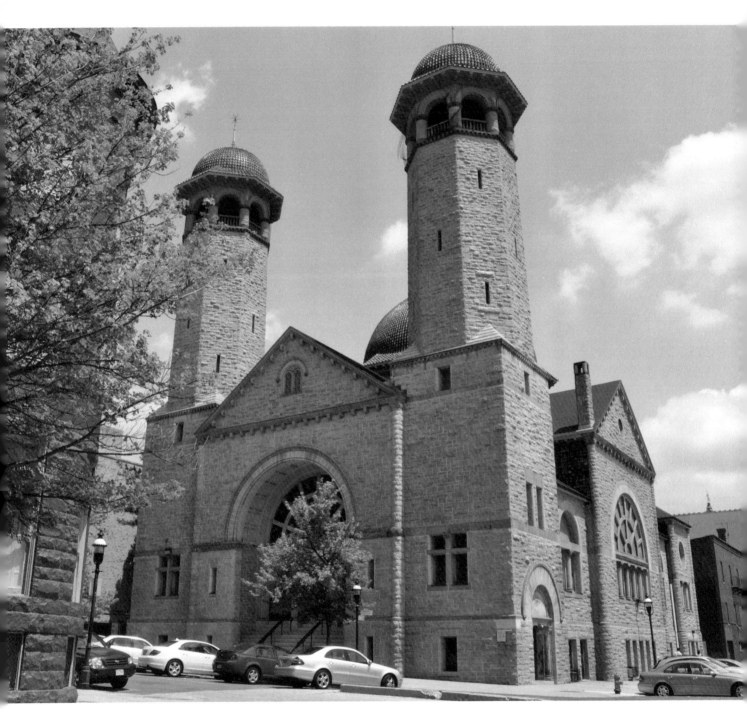

Berea Temple was the first example of Byzantine architecture in Baltimore when it was constructed in 1891.

1891
Architect: Charles L. Carson

A fine example of Byzantine architecture in Bolton Hill

Tucked away on a side street in the Bolton Hill neighborhood of northwest Baltimore, Berea Temple is a rare example of Byzantine architecture in Baltimore with minaret-like towers and a large dome covered with striking orange and brown tiles. This house of worship has served both Jewish and Protestant congregations. The building was constructed in 1891 by the Baltimore Hebrew Congregation when it moved from its original home on Lloyd Street (see Lloyd Street Synagogue). The new building was named the Madison Avenue Temple. In 1951 when the Baltimore Hebrew Congregation moved farther north and west, the Berea Temple of Seventh Day Adventists purchased the property for $12,000. The Berea Temple congregation, organized in 1900, had occupied various buildings in Bolton Hill before purchasing the Madison Avenue Temple.

Constructed of granite from Port Deposit, Maryland, and trimmed with Ohio sandstone, the rough-hewn exterior exudes strength and permanence. The triple-door entrance with a large fan window above is within a recessed arch. A pediment roof with dentil molding is above the entrance arch.

Extending above and on either side of the entrance are slender 105-foot towers. The tower roofs are dome shaped and covered with the same orange and brown as the main dome. The base of each dome flares outward like the brim of a hat. The roof is supported with columns and balustrades, providing an open space beneath. The towers can be seen from a distance and appear to be standing guard over the large central dome. Loopholes in the masonry of the octagonal towers resemble castle fortifications. The south side of the building is similar in design

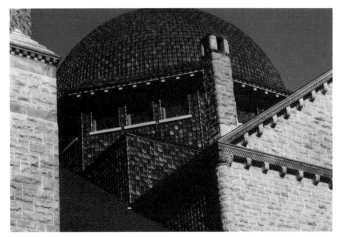

Straight roof lines contrast with the curved orange and brown tiled dome.

to the front. The main dome is most visible from this side. The octagonal shape of the dome replicates the domes of the turrets, and beneath its brim is a row of clerestory windows.

The arches on the exterior are replicated in the interior, which is divided by four large arches supported by massive cinnamon-colored marble columns. The bronze capitals of the columns are topped with light fixtures reflecting light upward. Two smaller arches define the four corners of the nave, and each arch is painted with a gold egg-and-dart band, and the interior is pale yellow. Within the four spandrels between the arches are liturgical paintings. One shows an hourglass above the North American continent, one shows Jesus with a lamb, another the Gates to Heaven, and another Jesus with angels.

Under the main dome is an octagonal ceiling. Clerestory windows in geometric designs of blue, green, and yellow light the interior. There are three large, fan-shaped stained glass windows, one on either side of the nave and the other above the rear balcony. The windows are predominantly yellow with floral designs. Underneath the fan-shaped windows are five rectangular windows with geometric designs of green and yellow.

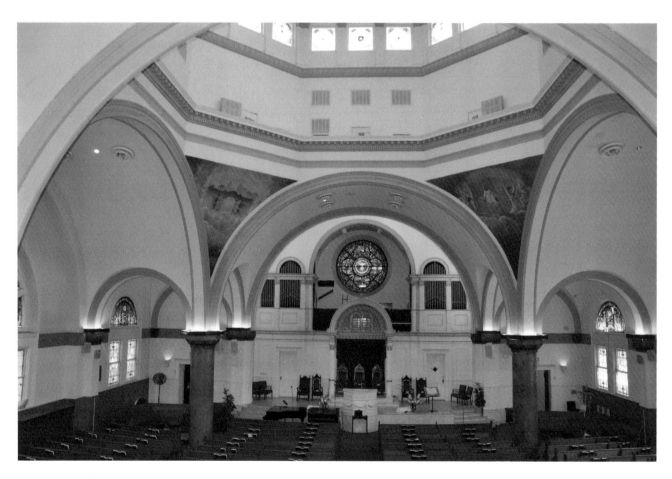

Clerestory stained glass windows above the octagonal ceiling provide light to the interior. Above the altar is a blue rose window.

The apse on the eastern end of the sanctuary features a brilliant blue rose window with a dove at the center. The marble lectern engraved with the Star of David rests upon an elevated marble platform. Behind the pulpit is a barrel-arched marble structure supported by slender Corinthian columns. This structure was moved from the Lloyd Street Synagogue and displays two tablets inscribed with Jewish letters. Carved high-backed chairs are on either side of the lectern.

Numbers are carved into the ends of the original oak pews along with a decorative design. The church can seat 1,200 people. The original organ is not operational at this time, but the pipes can be seen on either side of the rose window in the apse. The narthex features the original mosaic floor. Stairs to the choir loft are on each end of the narthex.

Berea Temple of Seventh Day Adventists was added to the National Register of Historic Places on November 7, 1976.

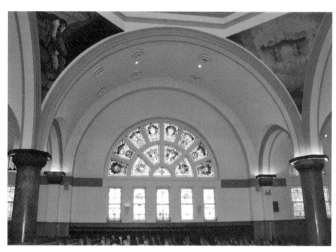

One of the three large fan windows in the sanctuary.

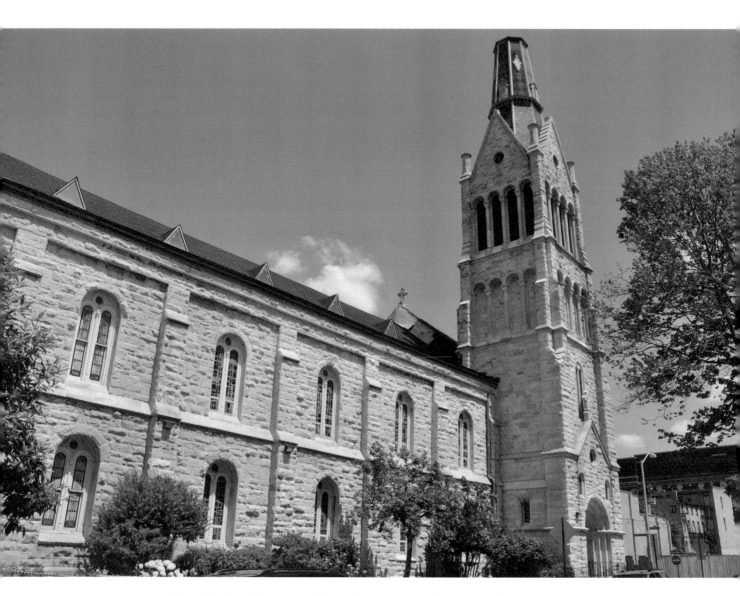

A five tiered bell tower on the south east corner dominates the gray stone exterior.

1868
Architects: Nathaniel Hutton and John Murdoch

**Mother church of the African Methodist
Episcopal denomination in Baltimore**

For more than two hundred years, Bethel has spearheaded efforts to address issues of particular concern to the African American community. The Bethel congregation was founded in 1785 when black members of Lovely Lane Methodist Church (see Lovely Lane) and Strawbridge Alley Methodist Church left those churches due to discriminatory practices. African Americans were drawn to the Methodist Church because of its antislavery position. However, when the African American congregants were assigned to segregated seating areas, they left these churches to form their own church. At first meeting in homes, they organized as a prayer group under the name Bethel Free African Society. The group acquired its first permanent home in 1797 when it moved into the former German Lutheran Church on Saratoga Street.

In 1801, Daniel Coker came to Bethel Church. He was an inspiring speaker and educator who became Bethel's first pastor. Coker opened one of the first schools for African Americans in Baltimore and was influential in the founding of the African Methodist Episcopal Church in America at the 1816 Philadelphia Conference. The following year, Bethel AME hosted the first annual African Methodist Episcopal Conference. Some of the issues that Bethel AME has supported over its long history include abolition, education for African Americans, promoting black teachers in black schools, anti-lynching laws, assistance to blacks during the Great Depression and the Civil Rights Movement. Among the noted leaders who have addressed the congregation are Frederick Douglass, Marcus Garvey, Thurgood Marshall and Rosa Parks. Prominent members of Bethel include well-known educator Fannie Coppin, for whom Coppin State University is named, and John Murphy, who founded an Afro American newspaper in Baltimore.

In 1911, Bethel AME moved to its present location on Druid Hill Avenue when it purchased the St. Peter's Episcopal building constructed in 1868. At that time, the St. Peter's congregation joined Grace Church to form Grace and St. Peter's Church in Mt. Vernon (see Grace and St. Peter's).

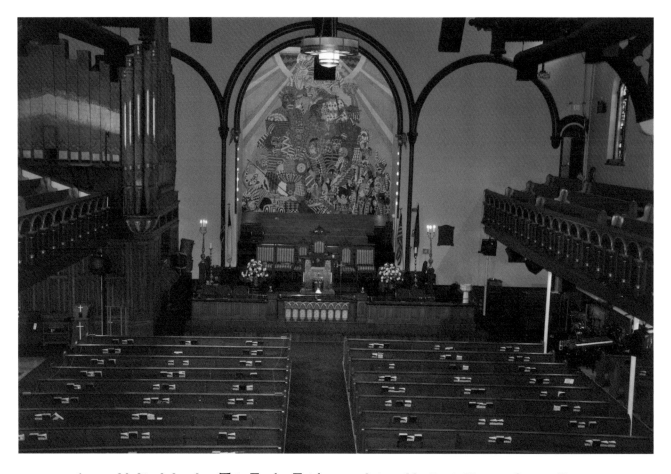

A mural behind the altar, This Far by Faith, *was designed by Bessie Yvonne Owens Everett.*

Bethel AME is constructed of gray cut stone and features a five-tiered bell tower topped with a copper steeple on one corner; on the opposite corner is a short, square tower with a crenellated battlement. The exterior facade of the church features three long, slender windows below a curved dripstone. A series of recessed arches outline the main entrance door, above which is a fan-shaped lunette window.

Upon entering the church, the eye is drawn to the mural on the wall behind the altar. The wall has three large arches outlined by wooden frames with a recessed central arch. In this arch is the mural *This Far by Faith*, designed by Baltimore artist Bessie Yvonne Owens Everett. Bands of color represent different periods in African American history, starting at the bottom with a band of green depicting life in Africa, a blue and lavender band showing figures in bondage, a red and orange band representing the period of Reconstruction, and a red and brown band representing the Civil Rights Movement. At the top are a husband and wife with a child, representing life. Streams of light radiate from the mural; at the pinnacle is a cross.

A wooden alter rail featuring a series of small arches inset with mosaics of gold crosses separates the chancel from the nave. The center pulpit displays a mosaic panel with a cross surrounded by lilies. To the left of the pulpit is a wooden organ case with greatly decorated pipes.

In 1979, two tiers of five stained glass windows were installed on either side of the church. The windows contain vivid colors in abstract designs. Over the main entrance at the rear of the church are three stained glass windows; the central one depicts the figure of Christ. Above is a fan-shaped window in brilliant colors of blue, green and red.

Massive trusses designed with arches and quatrefoil cut-outs bridge the high arched ceiling. In the roof between the trusses are the original small, triangular-shaped skylights of stained glass. The balcony extends around three sides of the nave. The pews and balcony can seat up to 1,700 people. At either side of the narthex are impressive curved staircases leading to the balconies. Stained glass windows cut into the walls light the staircases.

The altar rail is inset with mosaics of gold crosses.

The fan-shaped lunette window above the entrance.

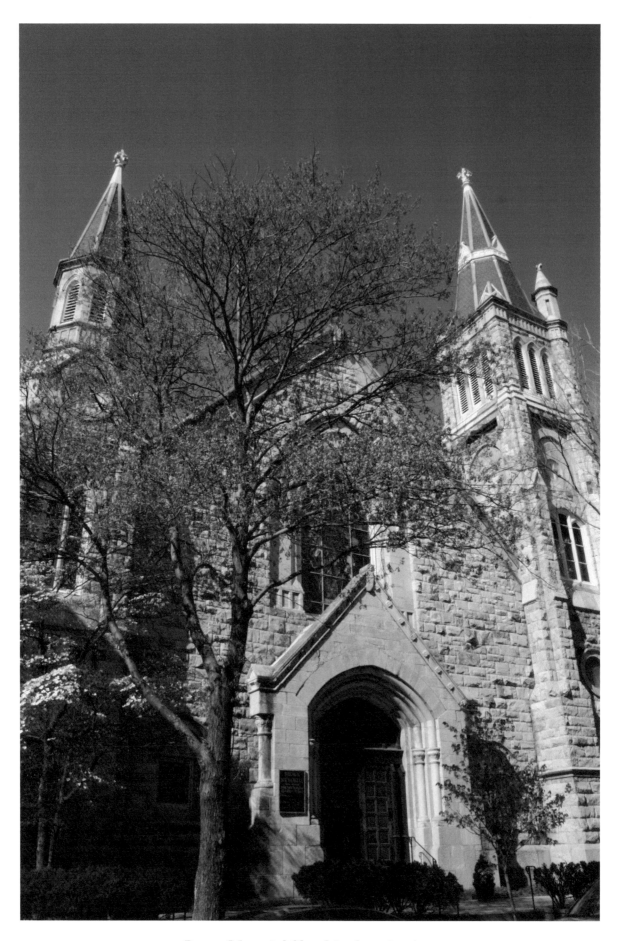

Brown Memorial Church in the springtime.

1870
Architects: Nathaniel Hutton and John Murdoch

One of the world's finest collection of stained glass windows with two of the largest windows ever created by Tiffany Studios

In 1869, Isabella Brown decided to build a fitting memorial to her husband, civic leader and prominent businessman George Brown. Brown was a founding member of the Baltimore and Ohio Railroad, which made Baltimore the leading transportation center in America at the time and created immense wealth for its shareholders. The church was intended to honor a man who used his wealth, business acumen, and position in the community for the common good. Mrs. Brown gave the then extraordinary sum of $150,000 to build a church in the growing, affluent northwest neighborhood of Bolton Hill.

The building is designed in a Gothic style and built of Baltimore County gray limestone; the front entrance has carved wooden double doors. There is a large Tiffany stained glass window above the entrance, and the gable roof above the doors mimics the large central gable of the building. A tall bell tower located to the right of the entrance extends above the roofline, while a smaller tower anchors the left corner. On the north side of the church, the brilliant blue colors of the immense Tiffany window stand out against the gray stone.

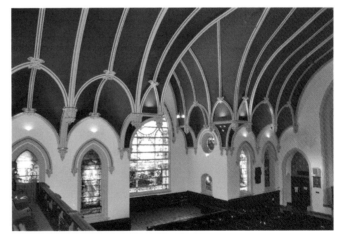

The blue interior complements the colors of the Tiffany windows.

Upon entering the church, the twilight blue arched ceiling soars above the nave. This blue complements the blue in the stained glass windows. The ceiling is accented with cream-and-burgundy-ribbed arches ending in gold-leaf embellished plaster pendants. Because there are no interior columns, the nave is open and expansive, allowing unobstructed views of its magnificent windows. Still visible on the original pews are the numbers for the pew holders. A balcony extends across the rear of the church.

The chancel, added in 1931, has an oak altar table elaborately carved with intertwining

grapes and vines. The choir stall, lectern, and pulpit are carved with floral designs. Seven small medallions on the rear wooden panels of the chancel represent the gifts of the Holy Spirit: wisdom, understanding, counsel, strength, knowledge, godliness, and holy fear. Sculpted on the pulpit are depictions of Old Testament prophets Elijah, Hosea, Jeremiah, and Isaiah. The four Evangelists are carved on the lectern with their accompanying symbols: an angel for St. Matthew, a lion for St. Luke, an ox for St. Mark, and an eagle for St. John. A Skinner organ, an Opus 839, installed in the chancel is one of the few remaining tonally intact Skinner organs. Noted organist Virgil Fox played here for ten years.

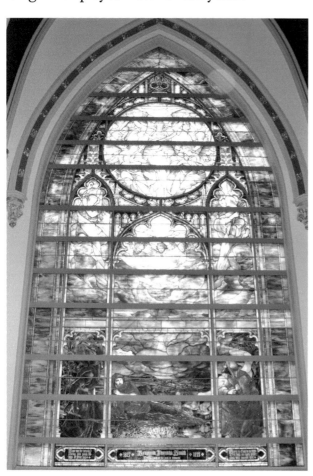

Tiffany window Annunciation to the Shepherds.

From an aesthetic standpoint, Brown Memorial is known for its seventeen stunning stained glass windows, twelve of which were designed by Tiffany Studios. Installed in 1905, the Tiffany windows on the north and south sides of the sanctuary are unusually large; each of them measures sixteen feet wide and thirty-two feet high. These windows are believed to be the largest ever made by Tiffany. The south window, titled *Annunciation to the Shepherds*, uses drapery glass to depict the robes of the shepherds and angels. The face of the middle angel in this window is that of the daughter of Benjamin Franklin Smith, who commissioned the window. The window is done in shades of lavender, green, and blue, colors frequently used by Tiffany Studios. The north transept window, named *The Holy City*, shows Jerusalem and a river flowing to the island where St. John recorded his revelations. Textured glass gives the impression of flowing water. In the distance are the colors of dawn—red, orange, and yellow.

Decorative hood molding ending in gold-trimmed pendants outlines each window. Two Tiffany windows are located on each side of the large side windows. Smaller jeweled windows tell biblical stories. The chancel features a five-paneled window by Wilbur H. Burnham based on the Twenty-third Psalm. This European styled stained glass window with tracery at the top contrasts sharply with the delicate colors and open design of the Tiffany windows. Glorious light from the windows soften the interior. Other windows were designed by the Church Glass and Decorating Company, the Gorham Company, and the Pittsburgh Plate Glass Company.

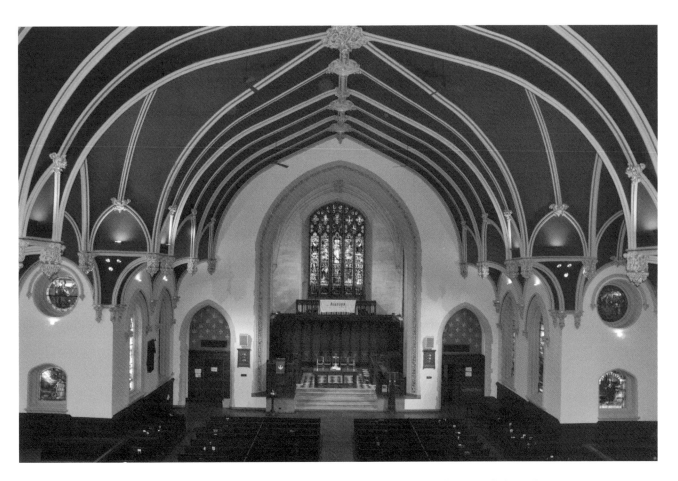

The beautiful blue ribbed ceiling, small Tiffany windows and chancel with the window, The Good Shepherd by the Wilbur Burnham Studio.

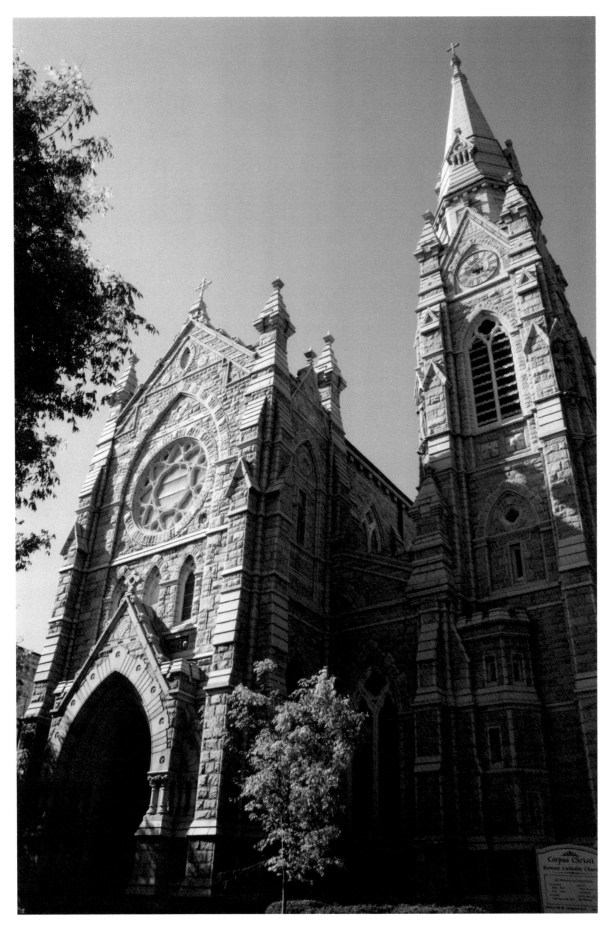

The exterior of Corpus Christi with Gothic style windows and doors.

1891
Architect: Patrick Charles Keeley

**The best example in the United States
of Florentine glass mosaics**

Shortly before Louisa Carroll Jenkins died in 1882, she asked her five children to build a Roman Catholic church as a memorial to honor their late father, Thomas Jenkins. The Jenkinses were a prominent Maryland family involved in business, philanthropy, and church matters since 1660. After Louisa Jenkins's death, her children decided to honor both parents. Patrick Charles Keeley, one of the foremost church architects of the time, was commissioned to design Corpus Christi which means "Body of Christ." It was the intention of the donors that this church be the most exquisite in Baltimore. The Corpus Christi parish was already established in the well-to-do area known then as Bolton Depot, now called Bolton Hill.

The church, constructed of gray granite with three-foot-thick walls, is in the Gothic style with buttressed walls, arched doorways, and windows. The steeple above the bell tower was added in 1912. At the base of the bell tower are statues of the four Evangelists standing on pedestals of their respective symbols: the ox for St. Mark, the lion for St. Luke, the eagle for St. John and an angel for St. Matthew. A large clock is on each side of the bell tower. Each evening at 7:04, the bells toll the De Profundis as a memorial to the biggest maritime disaster in Baltimore history. On a Corpus Christi men's outing in 1882 on the Patapsco River, sixty-three people drowned when a pier on which passengers were waiting to board a barge collapsed.

Features of the vestibule, such as the gold mosaic coffered ceiling, the marble-columned wainscoting, and the mosaic floor with an intertwining grape-and-wheat motif, are repeated throughout the sanctuary. Set in the vestibule's marble walls are two stained glass windows representing the archangels St. Michael, with his symbols of battle armor and sword, and St. Gabriel, holding a lily, a symbol of purity. Embedded in the mosaic floor is the crest of Michael and Isabella Jenkins, son and daughter-in-law of Thomas Jenkins. Michael was the leader among the Jenkins children in the building of Corpus Christi, as well as in the 1911 renovation done in honor of his wife. He also donated the land for the Maryland Institute College of Art situated next door. Michael and his wife were named Papal Duke and Duchess by Pope Pius X in 1905.

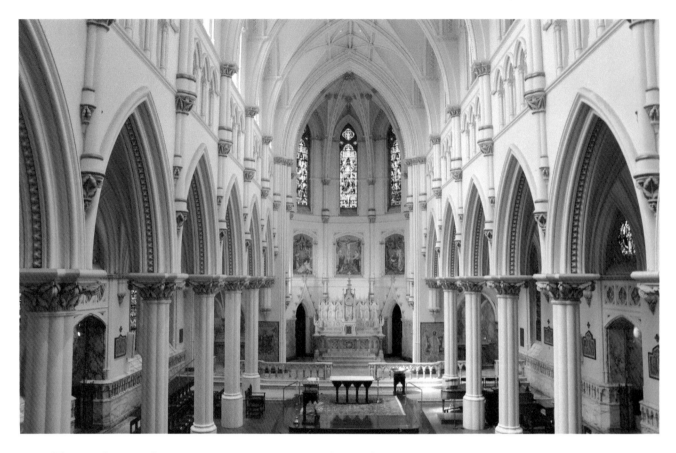

The windows and interior ornamentation were designed by the John Hardman Company of London.

The interior glitters and glows with gold, colorful mosaics and stained glass windows. Windows and interior ornamentation were done by the John Hardman and Company of London. Hardman was a student of August Pugin, a designer of the Houses of Parliament. Hardman incorporated grape and wheat designs throughout the church representing the communion service which serves bread and wine. Twelve stone columns, representing the twelve apostles, extend the length of the nave, supporting a ribbed, vaulted ceiling, below which are rows of clerestory windows. There are five stained glass windows in each side wall with alternating designs, one with a thorn bush and crown and the other with intertwining grapevines.

Mosaic Station of the Cross done in the Florentine style.

Mosaics are abundant in the church interior. The Florentine style is represented by a central figure painted on opaque glass with the surrounding area done in typical mosaic fashion with pieces of glass. The Stations of the Cross are also done in this style. Beneath each of the five stained glass windows in the apse is a mosaic depicting the principal events in the life of Christ. On each side of the apse are tall mosaic panels; in one, Christ stands upon shafts of wheat

The St. Joseph Chapel contains the tomb of Louisa and Thomas Jenkins.

and, in the other upon grapes. The altar is of marble from Sienna, Italy, with the Lamb of God carved in the center. Large praying angels are at each end of the altar. Smaller carved angels adorn the marble altar rail. In response to Vatican II, front pews were removed and a platform with altar table was installed.

The four chapels—the Lady Chapel, Chapel of the Sacred Heart, St. Joseph Chapel, and the St. Thomas Aquinas Chapel—along with the baptistery, are resplendent with gold mosaic ceilings, statues of saints, and stained glass windows. The St. Joseph Chapel contains the tomb of Louisa and Thomas Jenkins. The remains of Michael Jenkins, his wife, and his two sisters repose in the St. Thomas Aquinas Chapel. The baptistery has a window depicting the baptism of Jesus by St. John.

The large rose window in the choir loft represents the Archangel St. Rafael with Tobias. The original O'Dell tracker organ is still in place here. At the right rear side of the nave, a mosaic in the arch above the door illustrates the first mass said in Maryland on St. Clements Island in 1634.

This magnificent and costly church was never endowed. A restoration campaign was begun to ready the church for its hundredth anniversary in 1990. Funds were raised, and a fortuitous discovery helped. For years, a story had circulated that the church had an unknown treasure in a large wall safe from which the handle had been broken off. To investigate, a cutting torch was used to open the safe. Inside was a monstrance (a glass faced shrine in which the consecrated host is displayed) thirty-one inches high and

This mosaic depicts the founding of Maryland in 1634.

studded with fifty diamonds, one as large as three carats. It had been made in England in 1915 and was a gift to the church from Michael Jenkins in honor of his wife. The Jenkins family agreed that money from the sale of the diamonds could be used to help pay for the church's restoration. The jewels were replaced with non-precious stones, and the monstrance is now on loan to the Walters Art Museum.

Corpus Christi was listed on the National Register of Historic Places in 1978.

1. **Basilica of the National Shrine of the Assumption of the Blessed Virgin Mary**
 409 CATHEDRAL STREET

2. **First Unitarian Church of Baltimore**
 FRANKLIN AND CHARLES STREETS

3. **Old Otterbein United Methodist Church**
 112 W. CONWAY STREET

4. **Old St. Paul's Episcopal Church**
 233 CHARLES STREET

5. **St. Alphonsus Church**
 114 W. SARATOGA STREET

6. **St. Ignatius Roman Catholic Church**
 700 N. CALVERT STREET

7. **Zion Lutheran Church**
 400 E. LEXINGTON STREET

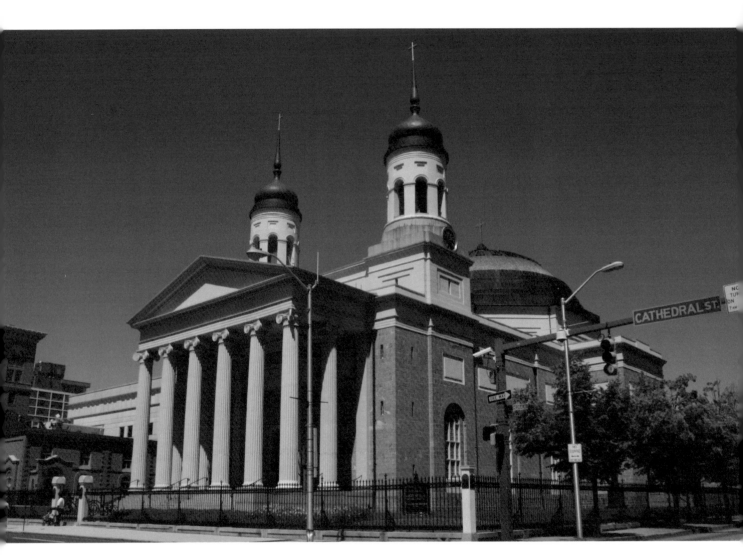

The portico and towers designed by Benjamin Latrobe Jr. were added in 1863.

1821
Architect: Benjamin Henry Latrobe

First Roman Catholic Cathedral in the United States

In 1789, Pope Pius VI commissioned the first American bishop, John Carroll, "to erect a church in the vicinity of Baltimore in the form of a cathedral church, in as much as the times and circumstances allow." At that time, the Diocese of Baltimore encompassed all of the original thirteen colonies and a third of what is now the United States; the largest concentration of Catholics was found in Maryland. Former Revolutionary War general John Eager Howard sold the land for the erection of the cathedral on a prominent hill in Baltimore. Bishop Carroll blessed the laying of the cornerstone on July 7, 1806; however, he did not live to see the dedication. The cathedral was under construction for the next fifteen years and dedicated on May 31, 1821, by Archbishop Ambrose Maréchal. Money was raised for the building through a public lottery, the selling of pews, and private gifts.

From the time of its dedication, the Cathedral played an important role in the education and ordination of priests and bishops. The Baltimore Catechism of 1884 was formulated here, and the first order of black nuns, the Oblate Sisters, was founded here. To honor the great history of the church, Pope Pius XI raised the Baltimore Cathedral to the rank of minor Basilica in 1937. This rank gives the privilege of displaying the papal bell, called the tintinabulum, and the papal caponium (umbrella), on either side of

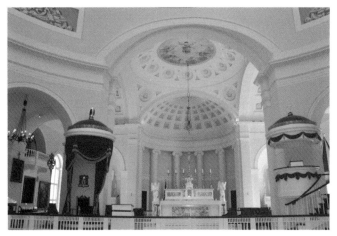

The chancel showing the altar, the cathedra to the left and the pulpit to the right.

the altar. In 1993, recognizing the fact that the Basilica draws pilgrims from all over the world, the National Conference of Catholic Bishops designated it a national shrine. Pope John Paul II celebrated mass in the Basilica when he visited Baltimore in October 1995.

Benjamin Latrobe, a prominent architect of the day who worked on the U.S. Capitol, donated his services to design the Cathedral. There were seven revisions of the design before the final

one was accepted. It is considered by students of architecture to be one of the finest examples of neoclassical design in North America. Built of gray granite quarried from Ellicott City, Maryland, the design is a cruciform shape dominated by a dome that is seventy-two feet in diameter and rises fifty-two feet above the nave.

The portico and the towers were added later. J.H.B. Latrobe enlarged his father's plans for the portico, which were approved in 1841 but not constructed until 1863. The portico features ten Ionic fluted columns that are thirty-five feet high, supporting a cast iron ceiling with a simple pediment above. The porch is sixty-one feet across and twenty-five feet deep.

J.H.B. Latrobe also designed the onion-shaped towers based on his father's drawings. The south tower containing the bells, which were cast in Lyons, France, was constructed in 1831. The clock in this tower, installed in 1866, was made in Paris. Now the clock and the ringing of the bells are coordinated by a satellite signal. A matching north tower went up in 1837, and a fine iron fence, designed by Robert Cary Long Jr., was erected in 1841. The cathedral was enlarged by thirty-three feet on the east end in 1890. Architects John R. Niernsee and E. Francis Baldwin designed the extension, allowing the main altar to be moved back to the original east wall and two side altars to be added.

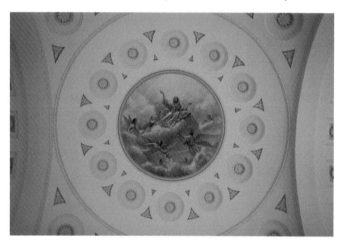

The painting Mary's Assumption into Heaven *is in the saucer dome above the nave.*

The last restoration of the Basilica was completed in 2006, changing the interior to resemble Latrobe's original design. Today, entering the church through the west door, one is impressed with its spaciousness, symmetry, and quiet strength. Eyes are drawn upward to the great dome, vaults, and saucer domes. The church is bathed in natural light from the clear glass Palladian windows, which replaced stained glass windows, and the clerestory windows in the oculus in the great dome. Pink rosettes on a blue field, the colors of Mary, decorate the ceilings of the domes as well as the barrel vaults of the interior. The weight of the great dome is supported by four massive pillars resting upon inverted arches in the crypt. *Mary's Assumption into Heaven* is depicted in the saucer dome above the western portion of the nave. The interior walls are of soft beige with contrasting cream moldings, and the floor is white marble. The pews are new but based on an earlier design. At the very rear of the church is a two-tiered balcony; originally, the lower balcony served as seating for African Americans and the upper balcony was for white people unable to afford a pew.

The main altar, called the Maréchal altar for Archbishop Ambrose Maréchal, is of white marble flanked by two wooden sculptures of kneeling angels. The front of the altar is inlaid with gray marble. Altars to St. Michael the Archangel and St. James the Lesser are placed in niches behind and to each side of the main altar. The Altar of Sacrifice standing before the main altar is of matching marble. An altar to Our Lady and an altar to St. Joseph are placed on the left and right

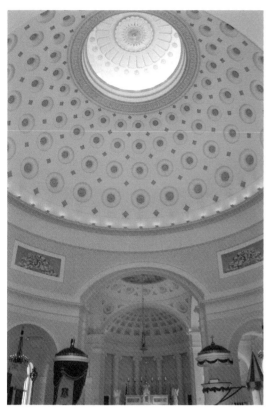

The oculus in the great rotunda sheds light into the interior.

of the chancel. A painting of Christ's Ascension into Heaven adorns the saucer dome above the main altar.

The archbishop's cathedra or chair placed to the left of the altar is the oldest in the United States and sits below a canopy draped with red fabric and topped by a bishop's miter. The "cathedra" is the teaching chair of the archbishop, and from its presence, the church building got the term *cathedral*. On a wall behind the cathedra is a red hat turned upside down. The hat contains pieces of Cardinal Gibbons hat. The pulpit, with a canopy matching the one over the cathedra, is reached via a circular staircase.

There is a small balcony with a deeply recessed interior over the door to the sacristy. It is said to have been built for Cardinal James Gibbons as a place where he could worship in private. A half dome at the eastern end of the chancel supported by six Ionic columns covers the staircases to the undercroft. During the 2007 restoration, frescoes painted in 1865 of the four Evangelists—Matthew, Mark, Luke, and John—were discovered in the great rotunda and were restored. There are balconies on either side of the rotunda, one of which contains the original Thomas Hall organ case from 1821. The organ was rebuilt and enlarged by Hilborne Roosevelt in 1884. The last restoration was in 1989. On the opposite wall is a two-tiered nuns' balcony. A curtain hung on the rod across the upper balcony provided a screen for cloistered nuns. Both balconies are supported by Ionic columns.

Gifts to the Basilica include the fourteen paintings depicting the Stations of the Cross, which have been cleaned and reinstalled. French King Louis XVIII gave the two large paintings on either side of the entrance. The candlesticks and crucifix on the altar are said to be gifts from Archbishop Maréchal's seminary students from Marseilles.

In the undercroft, with its massive inverted arches, is the chapel of Mary Our Lady Seat of Wisdom. Here also is a crypt, the final resting place of eight archbishops, including Carroll, and a small museum displaying some of the treasures of the Cathedral.

The Basilica was listed as a National Historic Landmark on October 1, 1972.

Inverted arches located in the crypt support the weight of the massive dome.

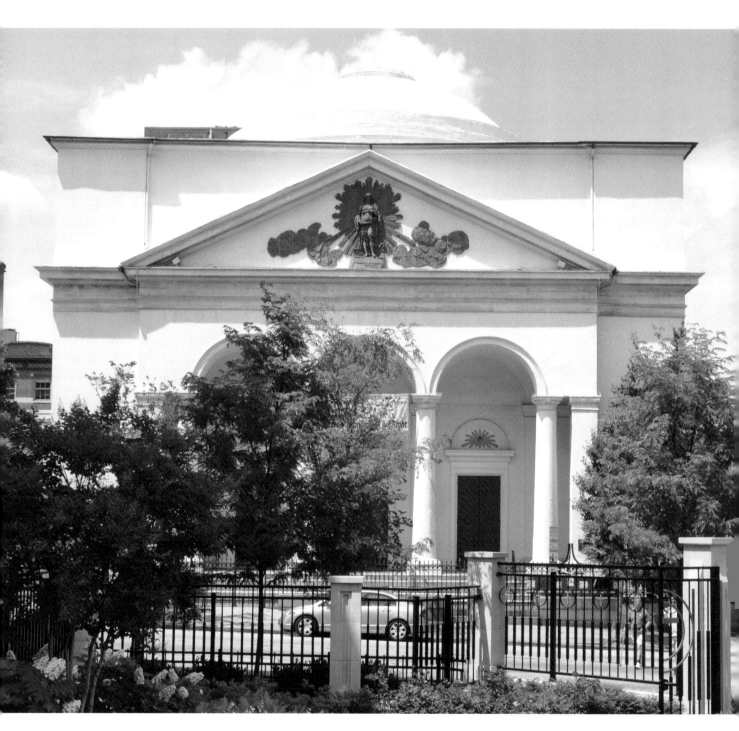

Maximilian Godefroy's design for the church is a perfect cube crowned with a sphere. The Angel of Truth sculpture adorns the pediment of the portico.

1818
Architect: Maximilian Godefroy

A historic church with a liberal tradition

In 1816 a group of prominent and wealthy Baltimore citizens including Henry Payson and Rembrandt Peale, artist and founder of Baltimore's first gas company, felt a need for a church of liberal faith. The outcome was the establishment of the First Independent Church of Baltimore. The church was the first church building constructed for the Unitarian faith in the United States. The group quickly raised the funds needed for construction of the church and hired one of the most respected architects of the day, Maximilian Godefroy, an exile from Napoleonic France. Godefroy also designed the 1812 Battle Monument on Calvert Street and St. Mary's Chapel on Paca Street.

The church was built just a block from the Catholic Cathedral, which was under construction at the time. A wooded site was cleared quickly, but there was no time to remove the tree stumps, so they remained in the church basement until as late as 1951.

Construction proceeded rapidly. Godefroy had a team of draftsmen working twelve hours a day on the design documents and started a foundry to produce bricks for the structure. The fact that the church was completed in a year is even more remarkable because the nearby Catholic cathedral drew heavily on Baltimore's labor force at the same time. On October 29, 1818, when the church was dedicated, the slaves who had worked on the construction of the church were freed.

Godefroy designed a building now considered to be a masterpiece of neoclassicism. The church is a perfect cube crowned with a sphere. The portico features four tall columns with Doric capitals supporting a pediment with a terra cotta sculpture, *The Angel of Truth*, designed by Godefroy and sculpted by Antonio Capellano, who also sculpted the figure of George Washington on Baltimore's Washington Monument. Henry Berge made a replica of *The Angel of Truth* when the original sculpture deteriorated.

Three entrance doors are situated under curved arches, mirroring the portico arches, and small terra cotta starbursts are above each door. The door on the east side of the porch is the only way to reach the organ loft. Two glass lanterns on wrought iron pedestals at the front entrance were among the first to be lighted by Peale's Gas Company. The walls are five layers of brick covered

The bird's eye maple lectern was designed by Godefroy.

with stucco fashioned to look like hand-hewn blocks of granite. The surrounding fence was designed by Godefroy.

Godefroy's architectural talents also extended to the interior furnishings. A copy of Godefroy's design for a harp-shaped organ case is displayed on the sanctuary wall. Still in use are the neoclassical chancel chairs that flank the marble altar; and the original pulpit of bird's-eye maple decorated with a band of gold palmettes.

From the entrance of the church, a center aisle leads to the main altar, made of marble. On the wall behind the altar are five wooden panels with symbols depicting various religions; a cross made of opalescent glass by Tiffany Studios is in the center panel. Above the panel is a Tiffany glass mosaic of the Last Supper. Note that all but one of the twelve disciples' halos have their names inscribed on them. Above the mosaic is a stained glass lunette, or half-moon, window designed with Greek symbols. The windows in the sanctuary were also made by Tiffany Studios as replacements for the original milk-glass windows. The geometric designs of the windows are in shades of green and yellow.

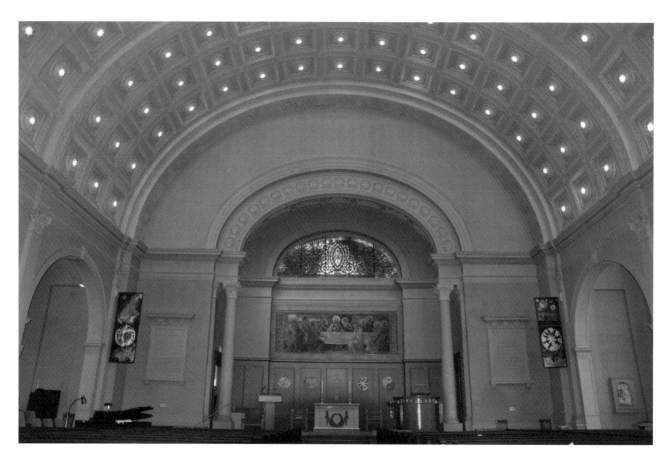

The mosaic of the Last Supper behind the altar was crafted by the Tiffany Studios.

Because of the high dome, acoustics were originally poor. Architect Joseph Sperry was hired in 1893 to remedy the problem. A barrel vaulted ceiling was installed consisting of 135 square panels; nine of the center panels are of stained glass. The other panels are a plaster rosette design with a light in the center. The ceiling is like a field of stars when the lights are turned on. At this time,

a Henry Niemann organ was installed, paid for by Enoch Pratt, a long-time member and trustee. Pratt established Baltimore's free, public library open to all regardless of sex, race, or creed. The baptismal font of French marble carved from one block of stone is a replica of the font in St. Martin's Church in Canterbury, England.

Around the nave are busts of important Unitarians, including founding members Henry Payson, Dr. William Ellery Channing, and Jared Sparks. On May 5, 1819, Dr. Channing delivered the famous "Baltimore Sermon" outlining the principles of Unitarianism at the ordination of Jared Sparks, the first minister of the church. Sparks went on to become president of Harvard University and to write a biography of George Washington. Baltimore's First Unitarian Church merged with the First Universalist Church of Baltimore in 1935, twenty-six years before the national merger of these two faiths.

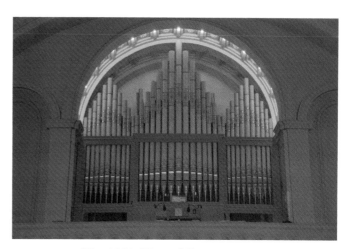

The 1893 Henry Niemann organ was paid for by Enoch Pratt.

The First Unitarian Church is a National Historic Landmark, listed on February 11, 1972.

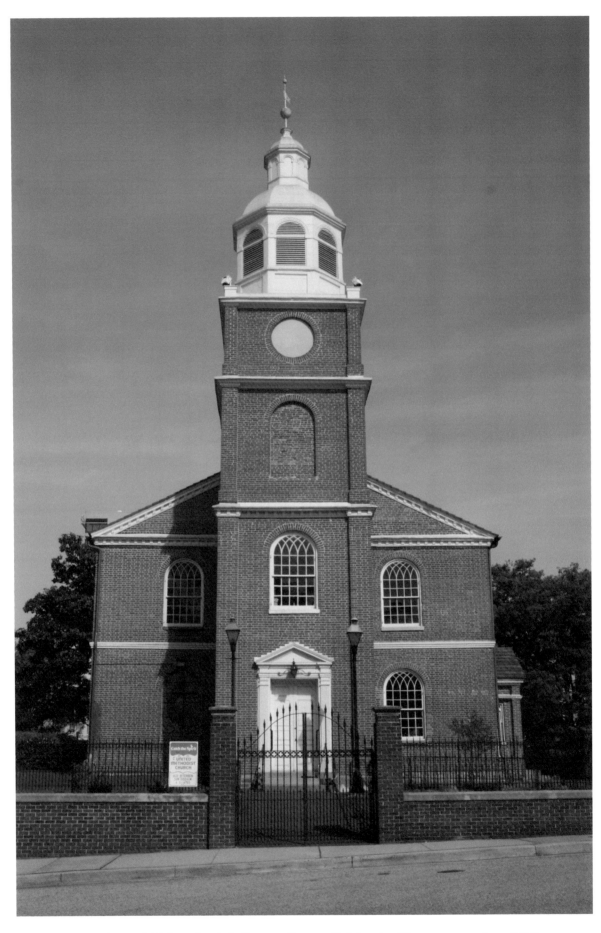

The bells in Old Otterbein's bell tower have tolled for significant events since 1789.

1785
Architect and Builder: Jacob Small

The oldest structure in continuous religious use in Baltimore

Old Otterbein, as it is known today, sits like a jewel among the high-rises, hotels, Baltimore Convention Center, and Camden Yards baseball stadium in Baltimore's Inner Harbor. The church was founded in 1771 as the German Evangelical Reformed Church of Howard's Hill in a simple log building to serve the religious needs of German Protestants who were prominent early settlers in colonial Baltimore.

Old Otterbein is named for the second pastor, Philip Wilhelm Otterbein, who came to America to minister to the German settlers. He became pastor at Otterbein in 1774. Otterbein served the congregation for thirty-nine years until his death in 1813 and is buried in the churchyard.

Old Otterbein broke away from the German Evangelical Reformed Church in 1789 to form the United Brethren in Christ Church, considered to be the first denomination of American origin. In 1946 the United Brethren in Christ Church re-joined the German Evangelical Reformed church to form the Evangelical United Brethren Church. A third merger forty years later united the Evangelical United Brethren Church with the Methodist church to become the United Methodist Church, which Old Otterbein is today.

After the Revolutionary War, the city's German population grew rapidly; the congregation became too large for the log building, and in 1785 the present building, which seats 240, was erected. Constructed of red brick originally used as ship ballast, the church cost six thousand dollars to build. The rectangular building features a two-tiered square brick tower topped with a white bell tower on the west side. One enters the church through the simple pedimented doorway at the base of the tower. A more elaborate door under a gable roof on the south side was the original entrance and features a half-moon window of yellow stained glass with tracery. Two tiers of five rounded, clear glass windows with delicate tracery at the top provide abundant natural light for the interior. Eighty-two percent of the glass in the windows is original.

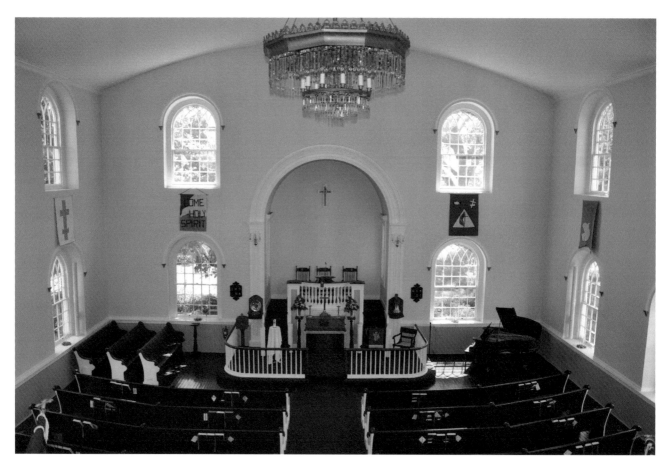

The pulpit was moved to the east wall of the church and the pews were turned to face it.

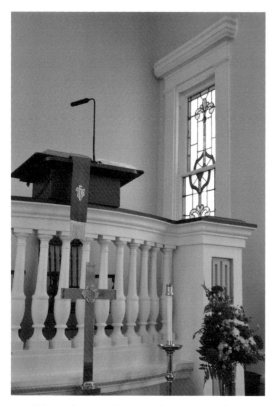

The pulpit and stained glass window.

Otterbein's two bells were cast in 1789 by the Whitechapel Foundry in London, which also cast the Liberty Bell. Engraved around the rim of one bell is the inscription "For Die Evangelische Reformirte Gemicndc auf Howard's Hill in Der Stadt Baltimore – 1789" (For the Evangelical Reformed Congregation on Howard's Hill in Baltimore Town, 1789). The bells were cast in two sizes to give a two-toned effect. They have pealed for many momentous events: they sounded the alarm in 1814 when the British invaded Baltimore, in 1904 when the Great Baltimore Fire destroyed much of the city, at the end of World Wars I and II, for funerals of four assassinated U.S. presidents, and when Charles Lindbergh landed in Paris in 1927.

The simple interior originally had balconies on three sides and the pulpit on the north wall. Two of the balconies were removed, and the pulpit was moved

to the east wall of the church. An apse was added behind the pulpit, and the pews were turned to face the pulpit. The minister's chair next to the pulpit belonged to Pastor Otterbein, and on the north wall is a portrait of him. Two small stained glass windows are on each side of the apse. The baptismal font and the altar were made by church members. A 423-prism chandelier lights evening services. The recently renovated Henry Niemann organ, located in the balcony—one of the few remaining in the city—is painted in shades of blue and lavender, accented with gold, and ornamented with scrolls.

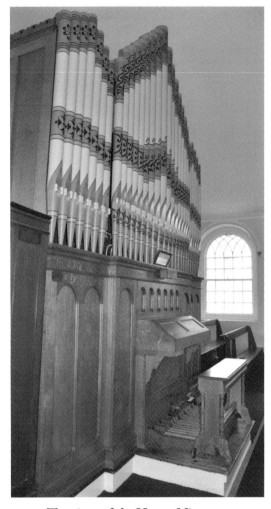

The pipes of the Henry Niemann organ are elaborately decorated.

On display in the outer lobby are portraits of former pastors, church documents, and a rare 1869 Sachse's Bird's Eye View Map of Baltimore. Other objects pertaining to the church's history include a miniature pew for children and a ladies' pew designed to accommodate dresses with bustles.

Today, the small but active congregation has found a unique way to raise funds to restore this historic church. Located just two blocks from Camden Yards, home of the Orioles baseball team, members of Old Otterbein sell bags of peanuts to people walking past the church on their way to the games. While ballast was used to build the church, peanuts are helping to maintain it.

Old Otterbein was listed on the National Register of Historic Buildings on October 28, 1969.

The present church is the third on the site. The two stone friezes are by Antonio Capellano.

1856
Architect: Richard Upjohn

Oldest congregation in Baltimore

The St. Paul congregation was one of thirty parishes established in Maryland by the Church of England in 1692. The congregation first worshipped in a log cabin in southeast Baltimore in present day Dundalk. The first of three churches was built in the 1730s on the current site, a high point in Baltimore overlooking the harbor. Old St. Paul's stands on the only property that has remained under the same ownership since the survey of Baltimore Town in 1730. The second church on the site, designed by Robert Cary Long , was constructed in 1817 and burned down in 1854. Among the elements of the church that survived the fire are a baptismal font designed by French architect Maximilian Godefroy, the bishop's chair, part of the *Suffering Christ* window, and the two stone exterior panel friezes.

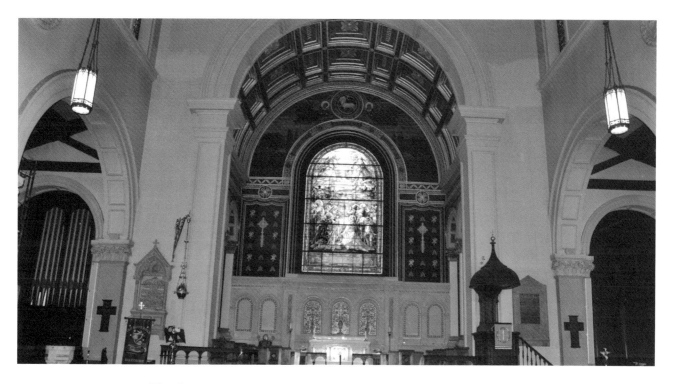

*The Great East Window, with the Lamb of God mural above and
the Tiffany reredos below dominates the chancel.*

The present church, dedicated in 1856, was designed by Richard Upjohn. Using the surviving foundation and red brick walls, Upjohn designed the church in the Italian Romanesque style. The front features a three-arched portico, above which are the two surviving panel friezes separated by a great rose window, one frieze depicting Moses and the other Christ by the artist Antonio Capellano. Capellano also sculpted the angel's head above the entrance of the First Unitarian Church (see First Unitarian Church). The Upjohn design included a six-story bell tower to the left of the portico, providing balance to the facade, but the full tower was never built.

The focal point of the interior is the Great East Window, located under a coffered barrel vault ceiling. The window, by Helen Maitland Armstrong, depicts the Glorification of God. Around the top of the window is a mural showing the *Agnus Dei,* or "Lamb of God" triumphant, and two angels. In red panels on either side of the window are the Greek letters chi and rho, the first two letters of the word *Christ,* and alpha and omega, representing the beginning and the end. Under the window is a Caen stone reredos, or screen, by Louis Comfort Tiffany

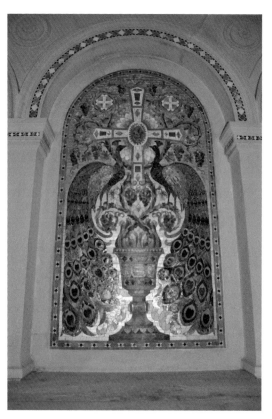

The cross in the middle panel of the reredos is embellished with peridot.

depicting Christian symbols, including the peacock representing the Resurrection. The cross in the middle panel of the reredos is embellished with peridot. Four arches supported by columns with gilded Corinthian capitals are on each side of the chancel. The altar of white carved marble in three sections symbolizes the Holy Trinity, and the altar rail and communion rail repeat the rounded arch design of the interior. A great Romanesque arch with Doric pilasters on each side separates the chancel from the nave. To the left of the high altar is the bishop's chair that was saved from the 1854 fire. The delicately carved high pulpit features an onion-shaped canopy with a cross and an orb on top. A gilded eagle lectern is to the left of the chancel.

Six stained glass windows on either side of the nave are surrounded by stenciling. In the sanctuary, nine windows are by Tiffany Studios, and the others are by Connick Studios and the Clayton and Bell company. The Tiffany Company designed the great rose window above the entrance depicting the Holy Spirit. Beneath this is another Tiffany window showing the Suffering Christ. Clerestory windows done by Clayton and Bell and by Tiffany are on the north and south sides of the building. Above the clerestory windows are supporting wooden trusses.

The floor is of Minton tile, and the pews and pulpit are of American black walnut. Four arches on each side of the sanctuary separate the side aisles from the center pews. White plaster medallion symbols of the four Evangelists are on the arch spandrels. Throughhout the building

are memorial plaques, one dedicated to member Samuel Chase, a signer of the Declaration of Independence.

The Lady Chapel to the right of the chancel is dedicated to Mary and has Tiffany windows depicting St. Anne and St. Augustine. The original Roosevelt organ whose pipes are to the left of the chancel, has been redesigned over the years by the Skinner, the Austin and the M. P. Moller organ companies. The organ console is located between the chancel and the Lady Chapel. Carved wooden trumpeting angels flank the antiphonal organ pipes located below the rose window. The Godefroy-designed baptismal font carved of Italian marble and used today to hold holy water is also at the rear of the church. Children are baptized using the large, four-sided stone baptismal font in the northeast corner of the nave.

A small room in the rear of the church, formerly a chapel, features windows of *Christ and Child* by Clayton and Bell and the *Angelic Ministering Spirit* by Tiffany Studios. A reception area under the northwest tower has four stained glass windows by Connick Studios. In 1992, for the tricentenary celebration, a twenty-three bell Harrison Carillon was installed in this tower.

St. Paul's was listed on the National Register of Historic Places on March 30, 1973.

The bishop's chair that survived the fire of 1854.

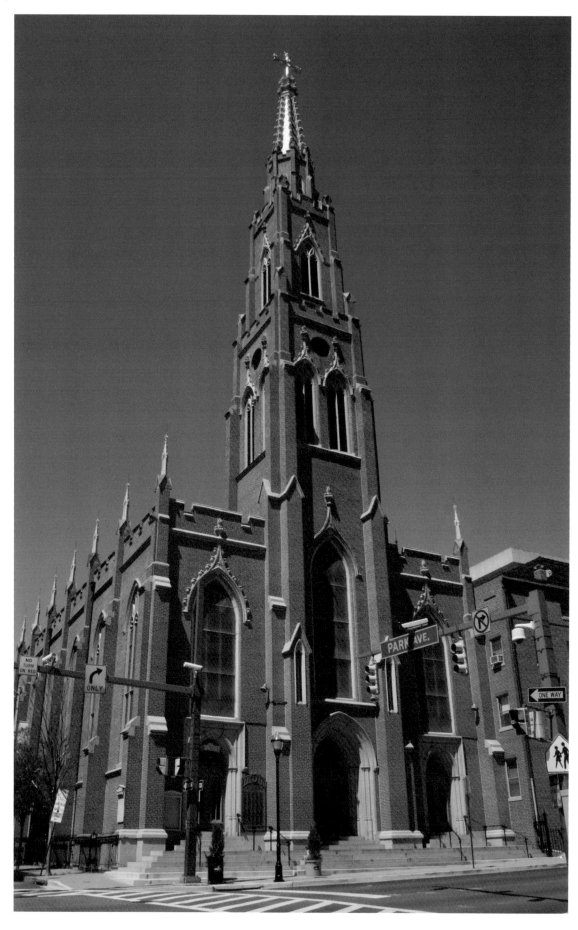

St. Alphonsus, designed by Robert Cary Long Jr., is in the Gothic revival style.

1845
Architect: Robert Cary Long Jr.

Parish church of a saint and a beatified priest

German Roman Catholics founded St. Alphonsus in 1845 to serve mass in their native language. The church flourished until the end of the nineteenth century, when several events occurred that affected its destiny. The surrounding neighborhood changed from residential to commercial, and the Great Baltimore Fire of 1904 destroyed much of downtown Baltimore, prompting people to leave the area. With the outbreak of World War I and the resulting strong anti-German climate, the parish fell into decline. However, St. Alphonsus later recovered and became home to Baltimore's Lithuanian Catholics.

In 1889 the Lithuanians acquired the Baltimore Hebrew Congregation's building on Lloyd Street (Lloyd Street Synagogue) when the Baltimore Hebrew Congregation moved to its new synagogue in Bolton Hill, now the Berea Temple of Seventh Day Adventists. The Lithuanians named their new church St. John the Baptist Roman Catholic Church. The Lithuanian parish worshipped there until 1904, when the building was sold to a new group of Jewish immigrants from Eastern Europe. St. John the Baptist Catholic Church then moved to the vacant church at Paca and Saratoga, today known as St. Jude's Shrine, (see St. Jude's Shrine) but not for long. Cardinal James Gibbons (1877–1921) , known for his daily walks and visits to parish churches, visited St. John the Baptist Catholic Church and shared his concern about the future of St. Alphonsus. At his suggestion, the Lithuanians obtained the deed to St. Alphonsus, and in 1917 it became their parish church. The Pallottine Fathers took over St. John the Baptist Catholic Church.

St. Alphonsus, in the Gothic revival style, was designed by Robert Cary Long Jr. The exterior is of salmon-colored brick with slightly buttressed walls and a battlemented roofline. A two-hundred-foot telescoped spire dominates the front elevation and is topped with a twelve-foot gilded gold cross. The McShane Bell Foundry in Baltimore cast the four bells in the tower, which were dedicated to St. Bartholomew, St. James the Great, St. Joseph, and St. Alphonsus, the largest bell. Along the west side are seven tall, pointed arched windows with tracery on the tops, located between vertical buttresses. Slender spires adorn the top of each buttress. Above the three entrance doors are arched stained glass windows.

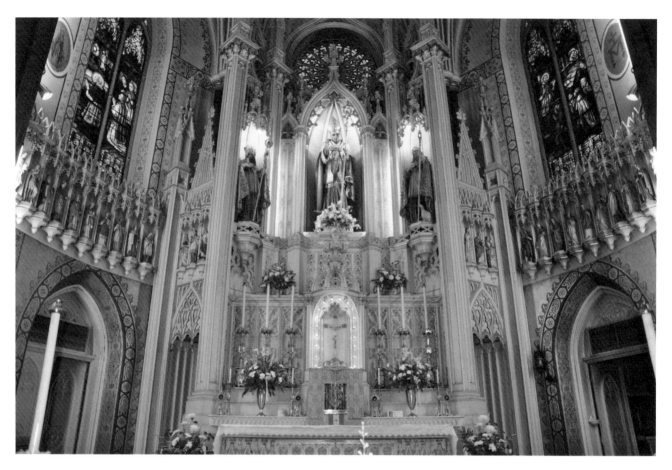

The great high altar is intricately decorated with multiple statues including one of St. Alphonsus in the center.

In the vestibule are carvings of the Pieta and the Crucifixion. The nave, supported by eight massive marbleized columns, soars fifty feet above the floor. Multiple ribs fan out from the top of the columns to form the vaulted ceiling. The ribs are topped with rosettes and outlined with stenciling. Looking out over the sanctuary provides a view of balance, order, and rich ornamentation. The interior is resplendent with delicate carvings: eighty-four polychrome statues of saints, the Stations of the Cross, stenciling, and stained glass windows. The carved, high-backed pews, with rental numbers still in place, date from 1877.

The immense high altar of painted wood dominates the apse and is intricately ornamented with gold-accented spires, columns, and platforms for statues of saints. A large statue of St. Alphonsus stands above the altar flanked by statues of St. Boniface and St. Martin of Tours. Set in twenty-six niches surrounding the apse are small

Eight massive columns support the high ceiling with ribs fanning out from the top.

figures of saints, including the Blessed Mother, St. Joseph, Jesus, Peter, Paul, John, Philip, Andrew, and Bartholomew. Statues of other saints, whose names are inscribed on their bases, are placed around the walls of the sanctuary. Polychrome Stations of the Cross are placed on either side of these statues. The communion rail is of marble with gilt accents done by H. Schroeder. Three large rose windows at the front of the church were done by F. Thomas of New York. Elaborately carved side altars one to St. Mary and one to St. Joseph match the center altar in ornamentation. A side chapel to the right of the apse has stained glass windows and a statue of Father Francis Seelos, rector from 1854 to 1857. The Moller organ installed in the mid 1960s is the third for the church.

A circular stairway winds up to a high, ornate pulpit supported by a slender, intricately carved column. Figures of the four Evangelists and Noah and Moses surround the base of the pulpit. In the ceiling of the pulpit canopy is a carving of a dove, and on top of the canopy is a statue of Jesus, the Good Shepherd.

St. Alphonsus has the distinction of having one of its parish priests, Father John Neumann, who was consecrated as a bishop in 1852, elevated to sainthood. A statue of Father Neumann is located in the apse. Father Seelos has been beatified and, should he become canonized, St. Alphonsus would be the only parish church in the world to claim two former pastors in the canon of saints.

St. Alphonsus was listed on the National Register of Historic Places on May 23, 1973.

The pulpit is adorned with statues of the four evangelists and topped with a statue of Jesus, the Good Shepherd.

The exterior of St. Ignatius has a prominent cornice , curved hood molds over the Palladian windows and Ionic pilasters.

1856
Architect: Louis Long

The Jesuit Church of Baltimore

In 1855, the Jesuits established Loyola College in Baltimore to teach high school and college age men. As was the Jesuit custom, the school was constructed before a church was built. St. Ignatius Roman Catholic Church, built in 1856, was named for the founder of the Jesuit order, who three hundred years earlier—in 1556—had opened a school in Messina, Sicily, devoted to scholarship and research, which are still the focus of the Jesuit order. Loyola College and High School have since moved to suburban locations, and St. Ignatius Loyola Academy, a school for inner-city youths, now occupies the school building. The church remains in its original location to serve a metropolitan congregation.

The three-part building fills the entire block between Madison and Monument Streets. Flush with the adjacent school building and Center Stage—a performance theater—the church is situated on the northwest corner of the block. The brick rectangular exterior is topped by a gable roof set back from a broken pediment roofline. A prominent cornice is the dominant feature of the exterior. Seven tall Palladian windows line the north side of the church and feature curved hood molds. The only other exterior ornamentations are the Ionic pilasters separating the windows. Two simple street-level entrance doors are located at each corner of the church.

The simple exterior of St. Ignatius does not prepare the visitor for the stunning Baroque interior. The walls are creamy beige and yellow with highlights of pale green. The interior is open and free of columns and balconies. Within the coffered ceiling centered above the nave is a painting in vibrant colors of the *Assumption of the Virgin Mary* done by the German artist Wilhelm Lamprecht. Elaborate plasterwork by Charles Anderson surrounds the ceiling

A painting of the Assumption of the Virgin Mary *in the ceiling of the nave.*

painting. Coved panels, ending behind a deep ornamented shelf, extend around the ceiling. The stained glass windows placed in an arched surround are of lavender, blue, green, yellow, and ruby red in geometric patterns. Ribbed pilasters topped with Corinthian capitals are placed between the windows, and the Stations of the Cross in bas-relief plaster are mounted on the pilasters.

The elaborate altar is two stories high with Corinthian fluted columns standing upon marble bases. In the arch above the altar is a dove, over which hangs a gold cross. Panels of gold-veined marble decorate the original white altar table, and the present Vatican II altar is of carved wood with Ionic fluted column legs.

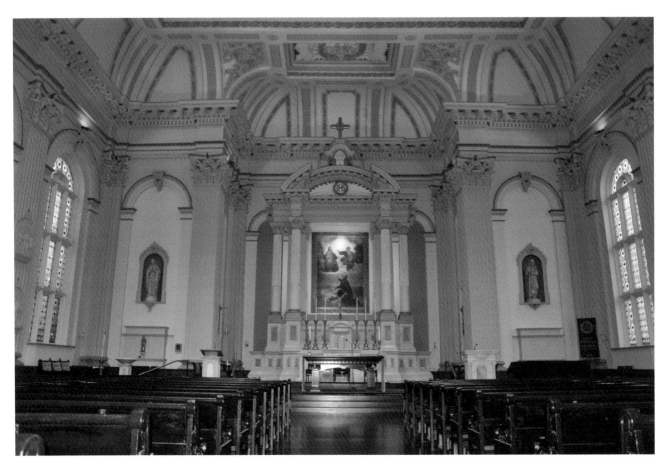

The focus of the Baroque interior is the elaborate altar and the Constantine Brumidi painting hanging above it.

Prominently displayed on the wall above the altar hangs a six-foot-by-twelve-foot painting, the *Mystical Vision of Saint Ignatius at La Storta* by Constantine Brumidi. Church records show that Brumidi traveled to Baltimore in December 1856 with the painting to see it installed. Brumidi's artwork is the major decoration in the rotunda of the Capitol in Washington DC. Two other large paintings in the church are attributed to Brumidi. They hang on the left wall of the sanctuary; one is of Jesus, and one is of St. Aloysius Gonzaga. These paintings are the only example of Brumidi's work in Baltimore. Statues of the Virgin Mary and of Joseph are placed in niches at the front of the sanctuary on either side of the altar.

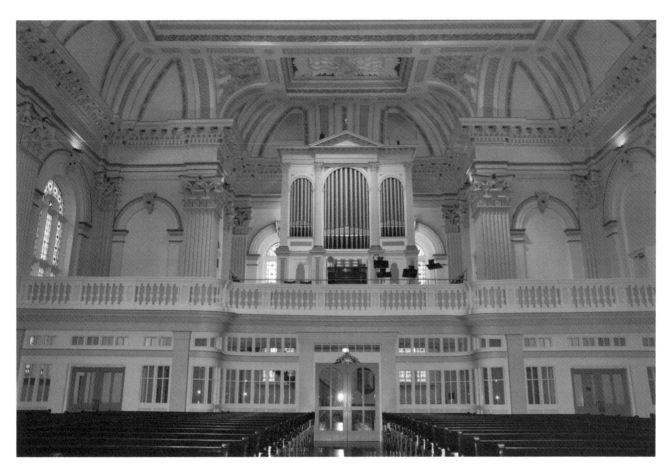

The handsome choir loft at the rear of the church.

The church is noted for its outstanding acoustics. The choir loft and organ console are located above the elaborately fenestrated narthex. In the ceiling above the choir loft is a carved golden harp resting upon what appears to be pillows of clouds. The 1857 William D. Simmons organ, made in Boston, was rebuilt in 1987. In the narthex are a Byzantine-style portrait of Mary and the young Jesus wearing jewel-encrusted golden crowns and statues of Jesus and St. Ignatius.

St. Ignatius was placed on the National Register of Historic Places in 1973.

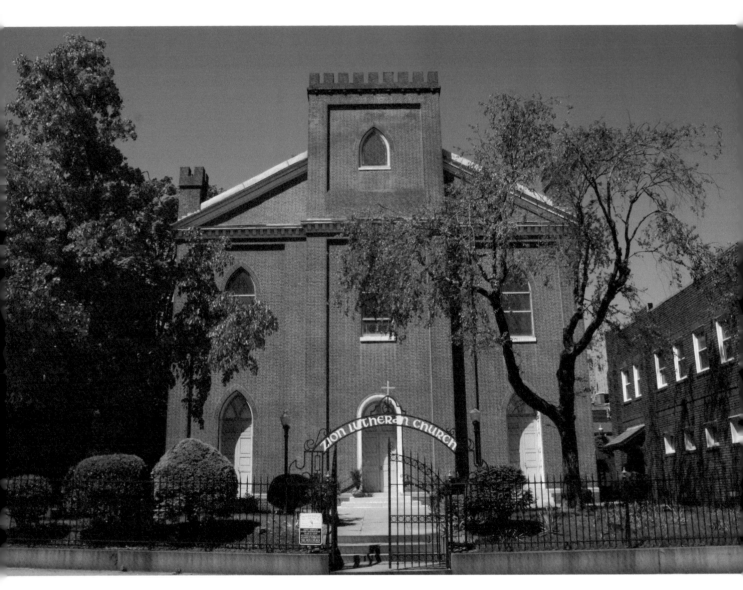

Zion Lutheran Church was built in 1807 for a German congregation.

1807
Builders: George Rohrbach and Johann Machenheimer

**The center of German American life
in Baltimore for over 250 years**

Colonial Governor Horatio Sharpe, writing to Lord Baltimore in England in 1754, described Baltimore as "having the appearance of the most increasing town in the Province.... Few besides the Germans (who are in general Masters of small Fortunes) build and inhabit there." In 1755, Germans of the Lutheran faith used the facilities of Old St. Paul's, an Anglican Church, for their services. The small congregation of eleven members secured an itinerant pastor to preach and administer sacraments in their own language. Three years later, the Baltimore Lutherans built a simple log building on Saratoga Street (called Fish Street at the time). By 1807, the membership had grown to over three hundred. Of that membership, 265 members pledged the $12,559.50 needed to construct the third and present church.

Zion Lutheran Church is a two-story brick building constructed by church members George Rohrbach and Johann Machenheimer. The church has a square tower with a crenellated surround facing Gay Street. The roof has dentil molding under the cornice. On the north and south sides of the church are two rows of arched stained glass windows. There are two entrances: the main entrance on Gay Street and the other off the courtyard on Holliday Street. Arched iron gates are inscribed with "Zion Lutheran Church" at both entrances.

A parish hall with a tall, slender tower was added in 1912 and is reached through the Holliday Street entrance. Because it is similar in size and attached to the church, the parish hall can be easily mistaken for the church itself. The dominating feature of the parish hall is a large American eagle carved in stone by Hans Schuler above the entrance. A shield on its heart depicts a German eagle, symbolizing the German immigrant at the heart of America. This hall has two stories with a tiled roof. Tall brick pilasters separate

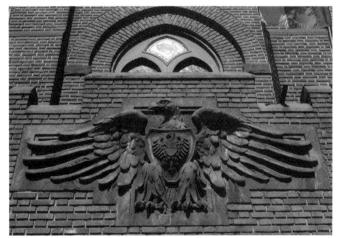

The large American Eagle carved by Hans Schuler features a German eagle on its shield.

45

the rows of stained glass windows, and above the windows are zodiac symbols, including the fish, crab, ram, bull, and twins.

Creating a peaceful oasis in Baltimore's busy civic center, Zion's gardens feature flower beds, an arcade, walls with Mercer tiles, statuary, and commemorative plaques, including one with a piece of the Berlin Wall. Three early pastors of Zion are buried in the garden; Hans Schuler carved the monument for Pastor Julius Hofmann's grave.

The interior was rebuilt after a fire in 1840. Balconies curve around the sanctuary on three sides. Pews facing the high altar retain their doors and the numbers of their original owners. Seven steps lead to the high wooden pulpit, and behind the pulpit is a wooden panel on which are images of St. Michael and St. Roland, carved by Hans Eckstein of Nuremberg. Above the panel hangs a large wooden cross. Eckstein also carved the front of the lectern, which features a relief sculpture of five angels. One of the treasures of Zion is its silver communion service, handmade in 1799 by silversmith Lewis Buichle, a member of the church. These vessels have been used by every pastor since.

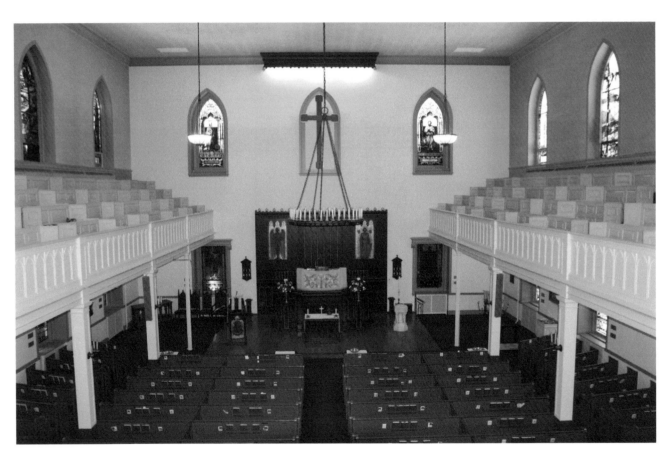

The church's interior features balconies, a high pulpit, and double rows of stained glass windows.

Double rows of stained glass windows brilliantly lit by the sun bring color into the otherwise neutral tones of the church. In addition to windows with biblical themes are windows dedicated to German achievements in arts, industry, and agriculture. The windows were created by the Foertsch-Lettau Art Glass Studio of Baltimore.

During a recent restoration of the interior walls, two biblical passages were discovered in the original German from the Book of Corinthians. The sayings relate to the scenes in the adjacent window. Translated, the message on the left wall is "If I not be an apostle to others yet doubtless am I to you; for the seal of my apostleship is ye in the Lord." The message on the right wall next to the window of the Three Graces is "Faith, hope, and love but the greatest of these is love." To the right of the altar are a marble baptismal font and a modern "tree of life" votive sculpture. When lit, the sculpture resembles the burning bush. Portraits of early pastors hang in the narthex, which has curving stairs on either side that lead to the balconies and choir loft. Visible from the nave is a large portrait of Martin Luther on the rear balcony wall.

One of Zion's most influential pastors was Heinrich Scheib (pastor 1835–1895). He established the Scheib School in 1836 open to children of any denomination and offering instruction in German and English. The reputation of the school was such that, by 1865, it had an enrollment of 802 pupils. The Scheib School is credited with having the first parent-teacher association in the United States. A bell and a school bench from the Scheib School are located in the garden.

The Hofmann library located in the parish house has a valuable collection of rare Bibles and other books on theology, history, and literature. Zion's extensive genealogical archives trace the ancestries of Zion Lutheran Church members. The church continues to offer services in German on a weekly basis.

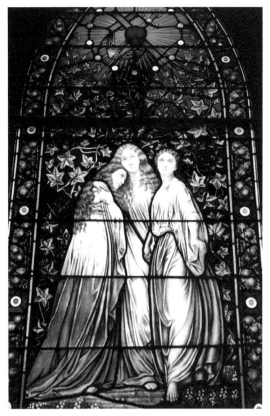

The Three Graces, faith, hope and love.

A bell and a school bench from the Scheib School are located in the garden.

CHAPTER 3
Historic Jonestown/
Little Italy/Fells Point

1 Lloyd Street Synagogue
15 LLOYD STREET

2 St. Leo the Great Roman
Catholic Church
227 S. EXETER STREET

3 St. Michael the
Archangel Church
LOMBARD AND WOLFE STREETS

4 St. Vincent de Paul Church
120 N. FRONT STREET

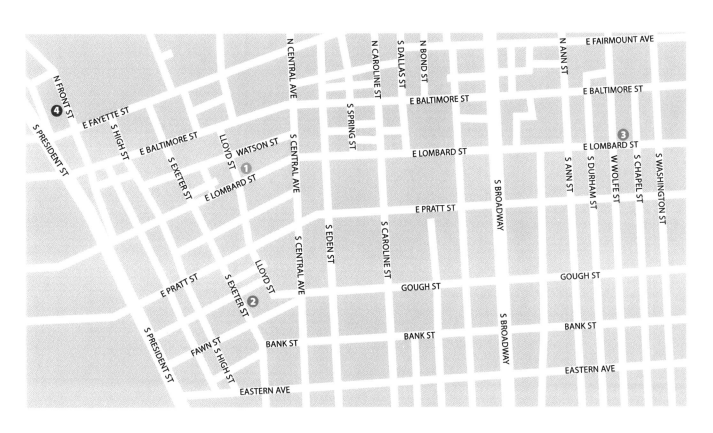

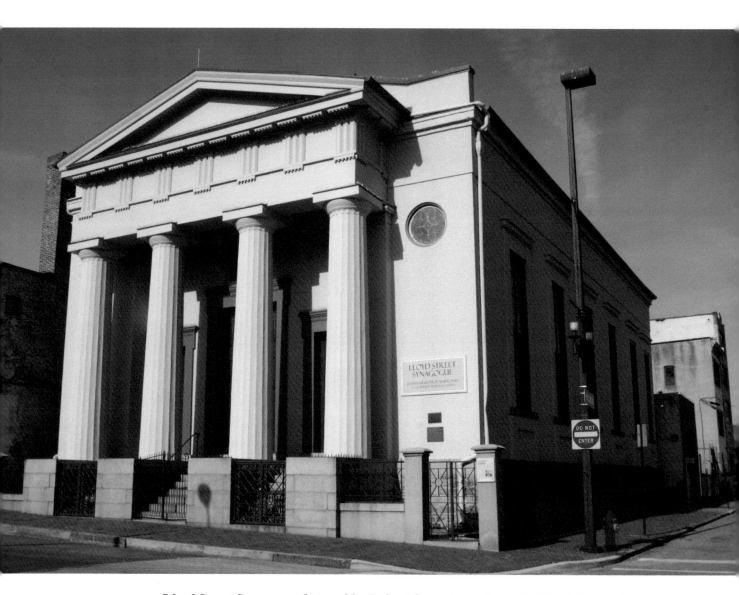

*Lloyd Street Synagogue designed by Robert Carey Long Jr. in the Greek Revival
style is rectangular with Doric columns supporting the pediment.*

1845
Architect: Robert Cary Long Jr.

**First synagogue built in Maryland and
the third oldest in the United States**

Political turmoil in Germany in the 1830s and 1840s resulted in an exodus of many Jews to the United States, large numbers of whom settled in Baltimore. The Baltimore Hebrew Congregation organized and met in a number of places in East Baltimore until it acquired a three-story building on Harrison Street. The Baltimore Hebrew Congregation hired Rabbi Abraham Rice to lead its worship services. Rabbi Rice arrived in Baltimore from his native Bavaria in 1840 and was the first ordained rabbi in the United States. The number of affluent German Jews was soon sufficient to warrant building a synagogue of their own. They acquired land on Lloyd Street and hired the most prominent architect in Baltimore, Robert Cary Long Jr., to design their house of worship.

Lloyd Street Synagogue is the oldest synagogue in Maryland and the third oldest in the nation. The two oldest synagogues are the Newport, Rhode Island, synagogue built in 1763 and the Charleston, South Carolina, synagogue dating to 1840. Choosing a Greek Revival style, Long designed a simple, rectangular brick building with a prominent portico of four Doric columns supporting a pediment. The symmetry of the front entrance is achieved by a large central door flanked by two smaller doors. Brick pilasters on the face of the building frame the entrance doors, and a three-part window is above the central door. Two small, round stained glass windows are placed high up on either side of the portico. In 1860 William H. Reasin designed the enlargement of the building with a thirty-foot extension on the eastern end. He added two windows on the north and south sides that are almost indistinguishable from the original four windows. Above each window is a brick cornice window head.

A small group of members broke off from the Baltimore Hebrew Congregation in 1871 and founded the Hebrew Chizuk Amuno Congregation. This congregation built a synagogue, the B'nai Israel Synagogue, on the same block of Lloyd Street in 1876. In 1889, the Baltimore Hebrew Congregation sold the Lloyd Street Synagogue to Lithuanian immigrants, and the building became St. John the Baptist Roman Catholic Church. The Baltimore Hebrew Congregation built a new synagogue, the Madison Avenue Temple (see the Berea Temple of Seventh Day Adventists) in northwest Baltimore, where many of its members had moved. In 1905, the Lloyd Street Synagogue building was acquired by a new group of Jewish immigrants from Eastern Europe and rededicated as an orthodox synagogue. They worshipped in this synagogue for over fifty years.

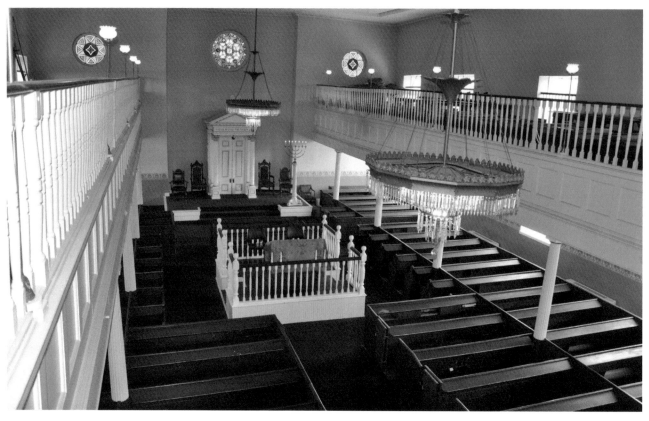

Interior view showing the box pews, balconies, the speaker's table within the bema, and the Ark.

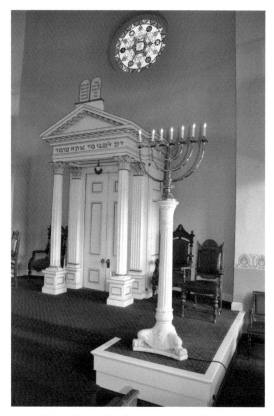

The ark and a large menorah stand upon a platform. Above the ark is the Star of David window.

As Jews left the neighborhood in the 1950s and moved to northwest Baltimore, the synagogue was closed, fell into disrepair, and was scheduled for demolition in the 1960s. Wilbur Hunter, director of the Peale Museum, alerted the Jewish community to the importance of saving this historic site. Money was raised to restore the synagogue, and at the same time the Jewish Historical Society of Maryland was founded. A major restoration of the building in the 1960s returned the interior to its original 1860 appearance.

A central aisle is flanked by the original box pews, and balconies on three sides are supported by Doric columns. A handsome, classically designed ark centered in a niche on the east end of the building contains three Torahs. Large standing menorahs are on either side of the ark, and above it is a large stained glass window with the Star of David at the center. Two large chandeliers from the 1860s hang over the center aisle and over the speaker's table. The speaker's

table is within a square, wooden-spindled surround called a bema. The restored building is used for special religious occasions, and the Jewish Historical Society of Maryland opened the building for public tours in 1964. A new museum building situated between the Lloyd Street Synagogue and the B'nai Israel Synagogue was constructed in the 1980s.

In 2008, the synagogue was restored and the exterior was painted a pale taupe, which, according to extensive research, was the color of the building after its 1860s expansion. In an exhibit hall in the basement is the old matzoh oven used by earlier congregations.

Lloyd Street Synagogue was listed as a National Historic Landmark on April 19, 1978.

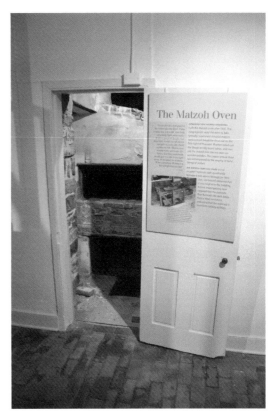

The old matzoh baking oven is located in the basement of the building.

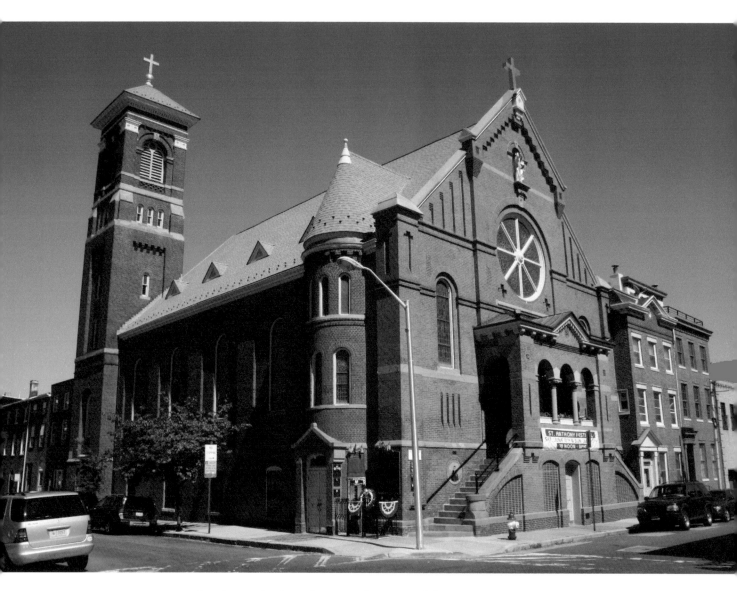

*A stairway leads to the covered portico of the main sanctuary. A large
rose window is beneath the golden statue of St. Leo.*

1881
Architect: Francis Baldwin

The heart of Little Italy

Little Italy and St. Leo are fused together as one community; they draw their identity from each other—the church from the community and the community from the church.

In the mid-nineteenth century, the neighborhood in downtown Baltimore just east of the Jones Falls, a stream flowing into the Inner Harbor, was a melting pot of immigrants from Germany, Ireland, and Italy. Following the Civil War, the tide of Italian immigrants grew significantly enough to warrant building a church of their own. Archbishop James Gibbons was sympathetic to the wishes of this growing Italian community, believing that the role of the church was paramount in the transition of immigrants to their new homeland. In 1881, the dreamed-of church became a reality when St. Leo was built. St. Leo was named for Pope Leo the Great, who was a defender of Italy and of Christianity during his reign from 440 to 461 AD and for the reigning pope in 1881, Pope Leo XIII.

The St. Leo church, dedicated on September 18, 1881, was designed to accommodate large numbers of parishioners. The congregation had 900 Italian members and 1,500 non-Italian members, and two sanctuaries were used to hold simultaneous masses for the parishioners. The first mass was held in Italian.

An outside stairway to a covered portico leads to the upper sanctuary. On the wall behind the stair railing is a large, circular mosaic of St. Gabriel. The front façade has a gable roof. Under the peak of the roof is a golden statue of St. Leo, the patron saint. Beneath the statue is a large rose window, and on each side of the church are two levels of stained glass windows. Located at the northeast end of the church is a square bell tower, topped with a gold cross that contains a two-thousand-pound bell from the McShane Bell Foundry in Baltimore. A half turret on the northwest corner features the side entrance to the lower sanctuary. Memorial plaques of St. Leo's parishioners, many with photographs, are placed on the wall near this entrance.

Inside, four bold arches resting on delicate fluted columns separate the side aisles from the main body of the church, and handsome chandeliers hang from the center of each arch. Frescoes of angels on the barrel vaulted ceiling look down upon the congregation. The interior is accented with bright colors of blue, gold, and red.

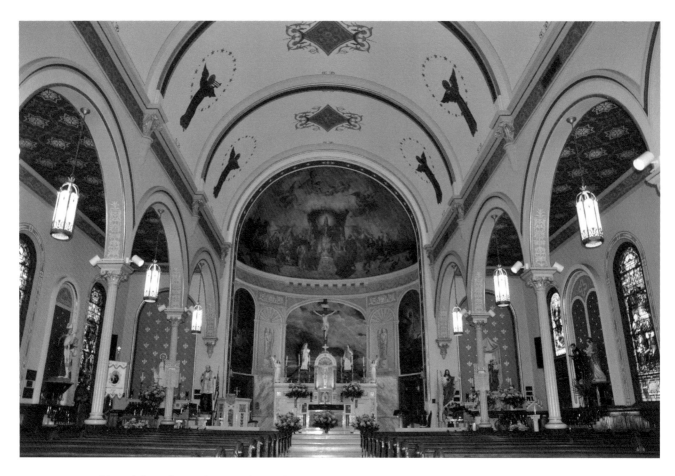

Chandeliers hang from arches. Frescoes of angels are on the barrel ceiling. A mural by Louis Jambor The Glorification of St. Leo *is above the Carrera marble altar.*

A mural by Louis Jambor, a Hungarian artist—completed after his death by Earl C. Nieman—of the glorification of St. Leo dominates the upper portion of the semicircular apse. Paintings of the Nativity and the Resurrection are on the lower curved walls of the apse. The large white Carrera marble altar has statues of angels on either end, and the tabernacle has gold

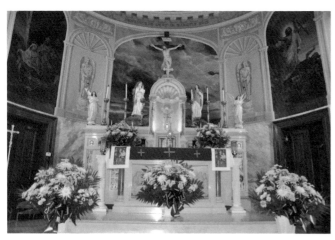

Statues of Mary and St. John stand on a replica of the rock on which Peter would build the church. A large crucifix hangs above.

doors. Above the tabernacle a cross and dove are surrounded by a curved gold mosaic wall beneath a shell dome. A large crucifix hangs directly above the altar, and the communion rail has yellow marble Corinthian columns. A replica of the rock on which St. Peter would build his church is behind the altar along with statues of Mary and St. John. The white marble pulpit is inlaid with mosaics of a lion and a ram.

The Sacred Heart of Jesus and a statue of St. Vincent Pallotti are on either side of the chancel arch. Side altars of the Shrine of

the Blessed Mother and of St. Anthony flank the apse. On the south wall of the sanctuary stand statues of St. Gabriel and St. Anthony. A polychrome statue of St. Leo stands on a pedestal on the north wall. Near this wall is a free standing bronze statue of the monk Santo Padre Pio. The polychrome Stations of the Cross were installed in 1940. Statues at the rear of the nave are of the Pieta and Our Lady of the Rosary. A rear altar beneath the balcony features mourners standing over the body of Jesus just removed from the cross.

The rounded windows, four on the north side and three on the south side, feature biblical designs with dominate shades of purple and blue. At the south rear wall, a window opening contains a painting of the Annunciation. There are confessionals along the back. The rear balcony, extending the full width of the sanctuary, contains the original 1881 organ, which is still in use. The pews are original to the church.

Polychrome Stations of the Cross.

A festival in honor of St. Anthony is held each June. The Great Baltimore Fire of 1904 burned all of downtown Baltimore west of the Jones Falls area. Tradition has it that parishioners gathered on the east bank of Jones Falls to pray to God and St. Anthony to protect their homes and church from the fire. At five o'clock in the morning, a strong wind came up and blew the flames away from Little Italy, so the fire never crossed Jones Falls. The St. Anthony Society was founded with the belief that St. Anthony had intervened and saved Little Italy from the disastrous fire.

St. Leo the Great is on the National Register of Historic Places.

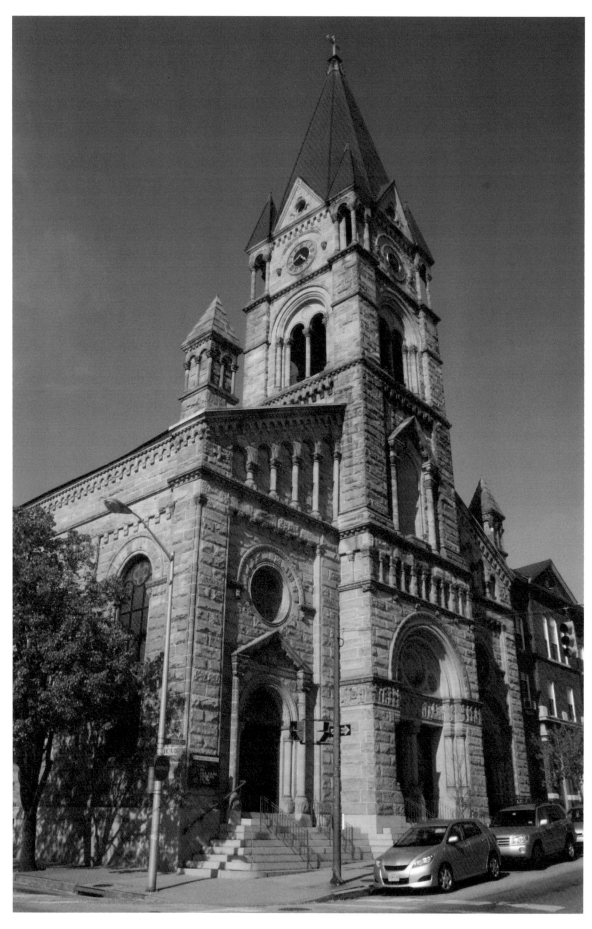

St Michael's is designed in a Romanesque style with a bell tower, arches, columns and friezes.

1857
Architect: Louis Long

Baltimore's official Spanish-speaking Roman Catholic Church

The Redemptorist Fathers asked architect Louis Long to design the St. Michael the Archangel Church in 1857. Situated on a prominent hill overlooking Fells Point, the church served the influx of German immigrants into the area. Bishop John Neumann—canonized in 1977—was the first pastor and laid the cornerstone. Until the outbreak of World War I, services were conducted in German. English took the place of German until the mid 1990s, when St. Michael's was designated the official Spanish-speaking church in Baltimore, reflecting the increased numbers of Spanish-speaking Catholics living in Fells Point.

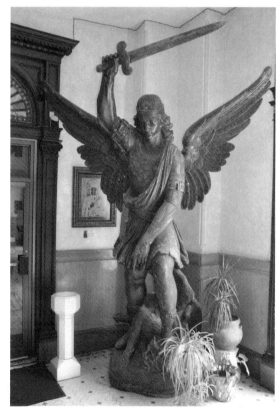

The church's exterior of Romanesque design has recessed arches, friezes, and columns. Originally constructed of brick, a major restoration in 1889 covered the exterior walls with rusticated sandstone blocks. At that time, the rear tower was removed and a new bell tower designed by A. A. Lehmann was constructed above the main entrance. An eight-foot gilded cross was placed atop the tower's green burnished copper spire. Five bells in the tower were made by the McShane Bell Foundry of Baltimore in 1890. The bells are named Clement in the key of A, Michael in the key of C, Mary in the key of E, Joseph in the key of F, and Alphonsus in the key of G. The largest bell weighs over two tons. There are clocks on each face of the tower, and two small corner towers balance the large central tower. A carved stone frieze of biblical scenes runs above the main entrance of the church, while gargoyles peer down from windows and ledges. In the base of the center tower is a niche in which an eleven-and-a-half-foot carved wooden

The imposing eleven and one half foot walnut statue of St. Michael the Archangel by Joseph Sudsburg.

statue of Michael the Archangel stood until 1992, when it was removed to the narthex to protect it from the elements. The statue, carved in walnut by Joseph Sudsberg, depicts Michael standing with his sword drawn and dominates the narthex.

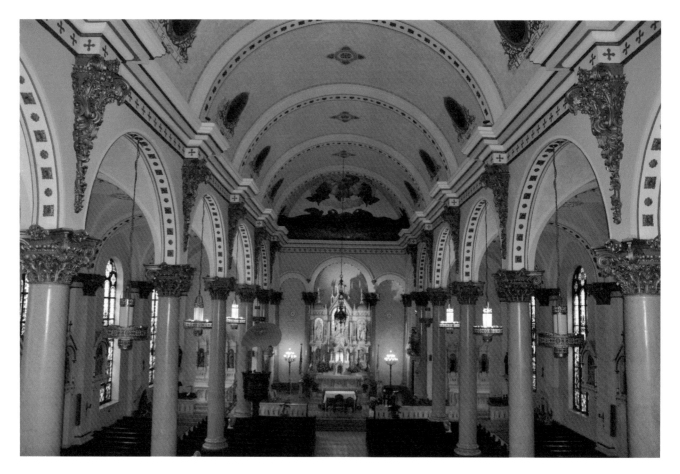

Free standing Corinthian columns support a barrel ceiling.

The large interior features ten freestanding Corinthian columns supporting a barrel ceiling. On the ceiling above the arches between the columns are paintings of the apostles. These are the work of Filippo Costaggini, the Italian artist who, after Constantino Brumidi's death, finished the frieze in the national Capitol. Fifteen hundred small electric bulbs are set into the arches. Carved wooden pews of white pine and mahogany sit on a low platform, making a recessed center aisle and providing seating for two thousand people. The ceramic blue and white tile floors in the narthex and nave are original to the building.

Carved of Carrera marble, the massive two-level main altar dates from 1896. Filling the chancel arch, the altar features three statues standing on platforms above the tabernacle. St. Michael, the patron saint of the parish, is at the center; to the right is a statue of St. Alphonsus, founder of the Redemptorist order; and to the left is St. Theresa of Avila, a Spanish Carmelite nun canonized in 1622. A painting of the *Transfiguration of Christ* is above the altar in the curved, recessed ceiling. Standing on platforms attached to the front columns are a statue of the Virgin Mary on the left and of Jesus on the right. To the right of the main altar is the St. Joseph altar

with statues of St. Joseph , St. John Neumann, and St. Elizabeth Seton. In the corner by this altar is a statue of St. Clement. On the eastern wall at the front of the nave is a copy of the painting *Our Mother of Perpetual Help*, the original of which is in Rome. The Blessed Mother altar to the left of the main altar features statues of Mary, St. Joseph, and St. Ann, the mother of Mary. In the corner by this altar is a statue of St. Gerard, the patron saint of mothers. A statue of Our Lady of Guadalupe is situated on the west wall at the front of the nave.

The raised pulpit is elaborately carved of oak and reached by a circular stairway. Placed around the pulpit are carved statues of Matthew, Mark, Luke, and John. A shell hanging over the pulpit enhances the priest's voice. Carved in the ceiling of the shell is an image of the Holy Spirit in the form of a dove.

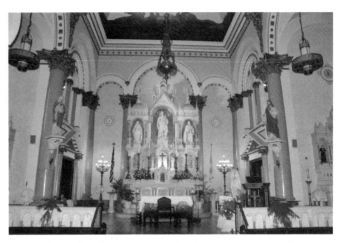

Above the Carrera marble altar are statues of St. Michael in the center; to the right is St. Alphonsus and to the left St. Theresa of Avila. On the front columns are platforms on which stand statutes of the Virgin Mary on the left and Jesus on the right.

Twelve stained glass Palladian-styled windows, installed in 1893, were created by Kettler's of Munich, Germany. They depict traditional scenes from the life of Christ. There are bull's-eye stained glass windows throughout the church, including two large ones located above the front doors flanking the main entrance. The Stations of the Cross along the side walls of the nave are between Corinthian pilasters and stained glass windows. The Stations of the Cross are brilliantly painted carved plaster placed within an arched enclosure with a descriptive title beneath each station.

In the rear of the church are three elaborately carved walnut confessionals, a copy of the Pieta, and a statue of St. Anthony. A recent addition is a panel depicting Our Lady of Peace. Because of their beauty, the old organ pipes were retained and remain in the choir loft, although the original organ was replaced in 1958. A small chapel with a marble altar and stained glass windows is entered from the narthex. A painting of the Black Madonna embellished with pearls hangs by the entrance to the chapel. In addition to the imposing statue of St. Michael in the narthex, there is a statue of St. Francis.

St. Michael the Archangel Church was listed on the National Register of Historic Places on May 17, 1989.

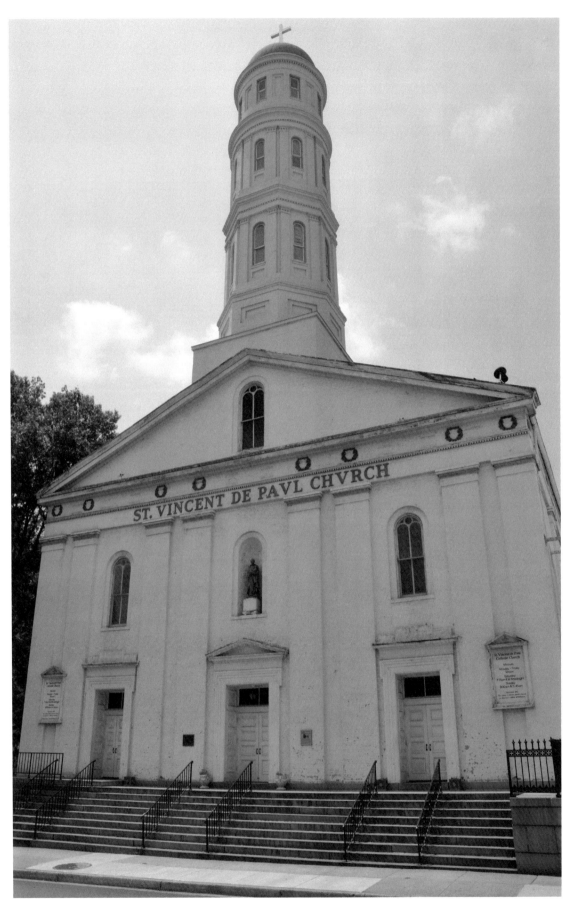

Front view of the neo-classic St. Vincent de Paul church showing the 150 foot three-tiered bell tower. A statute of St. Vincent de Paul is in a niche above the center door.

1841
Designer: Rev. John B. Gildea

Home of the Saturday midnight Printers' Mass

Built along the east side of the Jones Falls area in the Historic Jonestown neighborhood, St. Vincent de Paul Church is a prominent landmark in Baltimore today at the southeast end of the Jones Falls Expressway. The church is the oldest Catholic parish church building in Baltimore. It is named for St. Vincent, patron saint of poor children, orphans, and the disadvantaged. The plans for the St. Vincent de Paul Church in 1840 included the construction of an adjoining orphanage and school for boys.

Rev. John B. Gildea, the first priest, chose a simple neoclassical design for St. Vincent de Paul. Built in 1841, the church is rectangular with a pediment roof topped by a 150-foot-tall three-tiered bell tower on the east end. A gold cross sits on the copper dome of the tower. Simple double-pane windows encircle each tier of the tower. Fourteen bells cast by the McShane Bell Foundry of Baltimore were hung in the tower in 1873. Front Street was closed to traffic at the time so that horses using pulleys could hoist the bells to the tower. Double pilasters separate the Palladian windows on the exterior walls. Wreaths above the pilasters in the frieze are the only exterior adornment. In a niche above the center door at the entrance is a statue of St. Vincent.

When it was first constructed, St. Vincent's parish, in what was then the fashionable Old Town neighborhood, included wealthy members, such as Mary and Richard Caton (daughter and son-in-law of Charles Carroll of Carrollton, the last surviving signer of the Declaration of Independence and one of the richest men in America). However, the congregation began to change in the late 1840s with the migration of wealthier inhabitants of the neighborhood to more prestigious areas in Baltimore, such as Mt. Vernon. The St. Vincent's parish continued to grow with the influx of immigrants, especially Irish, who came to America to escape the Great Famine and to work on the canals and railroads.

Every fifty years since St. Vincent de Paul's construction in 1841, there has been a major renovation to the interior to reflect the architectural styles of the time. These renovations also have coincided with the church's semicentennial, centennial, and sesquicentennial anniversaries. The original sanctuary was largely unadorned, with a flat ceiling and balconies on three sides to seat the large congregation. The well-to-do sat in enclosed private pews on the sanctuary floor; less affluent parishioners sat in the balconies; free blacks sat to the sides of the balcony; and slaves sat in a second rear balcony.

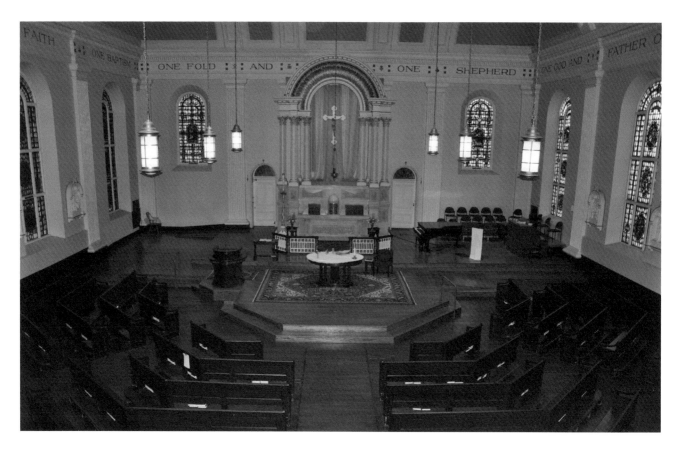

Pews encircle the Vatican II altar. Religious inscriptions are inscribed above the stained glass windows.

The lay light in the center of the ceiling admits natural light.

In 1890, the large congregation of seven thousand members decided to embellish the church's interior with Victorian elements to celebrate its fiftieth anniversary. George Frederick, architect of Baltimore's City Hall, was hired to adapt the interior. The side balconies and the rear second balcony were removed, and an elaborate baldachino (an ornamental canopy placed over the altar), supported by eight Corinthian columns, was erected over the marble altar. A domed tabernacle is part of the altar table, and a crucifix hangs on the rear wall beneath the baldachino. Frescoes were painted on the walls, stained glass windows were installed, and gold-leaf rosettes were added. A coved ceiling with a flat skylight, called a laylight, of etched yellow and green glass provided light to the nave.

In 1890, to accommodate the large congregation, especially after the removal of the side balconies, the pastor wrote to Rome to get a special dispensation to hold masses from late Saturday night to early Sunday morning for the benefit of the pressmen who worked late on Saturday night to print the Sunday papers. The Printers' Mass, as it came to be called, was very popular, and late-night revelers also took advantage of the opportunity to attend these masses before returning home. These masses continue today.

The church's interior was returned to a simpler style in 1940 for its centennial celebration, when the frescoes were painted over, doors were removed from the pews, and the windows were replaced with new stained glass windows by Henry Lee Willet Studios of Philadelphia. The three-part windows with brilliantly colored medallions in each section were dedicated to the seven sacraments and remain in the church today. The gold leaf removed from the 1890 embellishments helped pay for the restoration.

The adjoining male orphanage and school building was demolished in the 1970s and replaced with a park. The most recent renovation in 1990 combined changing the configuration of the altar area to reflect the liturgical changes of Vatican II and updating the church for its sesquicentennial celebration. Architects Murphy and Dittenhofer designed the interior to adapt to its new functions but kept architectural elements of earlier designs. A new, elliptical wooden altar was placed in front of the original altar to allow closer communication between the pastor and the congregation. Within the new altar is a stone from the old high altar that contains a relic of St. Vincent de Paul. The wooden altar has a frieze of wheat and vines to symbolize the bread and wine of the communion service, and twelve Corinthian columns supporting the table resemble those of the baldachino. The altar is placed upon a low, handicapped-accessible platform, or bema. A wooden ambo (lectern) placed to the left of the altar is used for Bible readings. Rich Oriental rugs add warmth to the altar area. The 1840 pews reconfigured into a radial design provide an intimate setting. There are no architectural features to obstruct the openness of the interior.

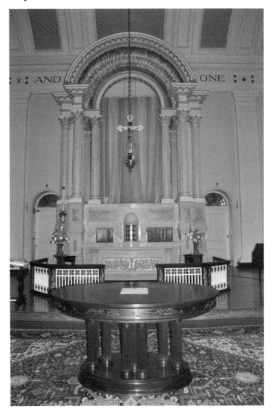

The Stations of the Cross between the tall Palladian windows are painted white with touches of gilding. Pilasters along the wall match the design of the exterior pilasters. Beneath the ceiling surrounding the sanctuary are scriptural phrases. Much of the wooden floor is original to the 1840s and contains clues to past configurations of the interior, including side aisles and footprints of balcony posts.

Below the rear balcony is a glass wall of five sections, which was part of the 1990 renovation, separating the sanctuary from the annex. The spacious area behind the glass enclosure is referred to as the gathering space.

Within the elliptical wooden altar table is a relic of St. Vincent de Paul. A baldachino stands over the original marble altar.

On either side of the gathering space is a staircase leading to the balcony, which still holds the organ pipes of an unused organ. A side chapel at the rear of the church has statues of St. Vincent, Mary, and Joseph.

The church was listed on the National Register of Historic places on February 12, 1974.

<div align="right">

CHAPTER 4
Seton Hill

</div>

① **Mt. Calvary Church**
816 N. EUTAW STREET

② **St. Jude Shrine**
309 N. PACA STREET

③ **St. Mary's Chapel**
600 N. PACA STREET

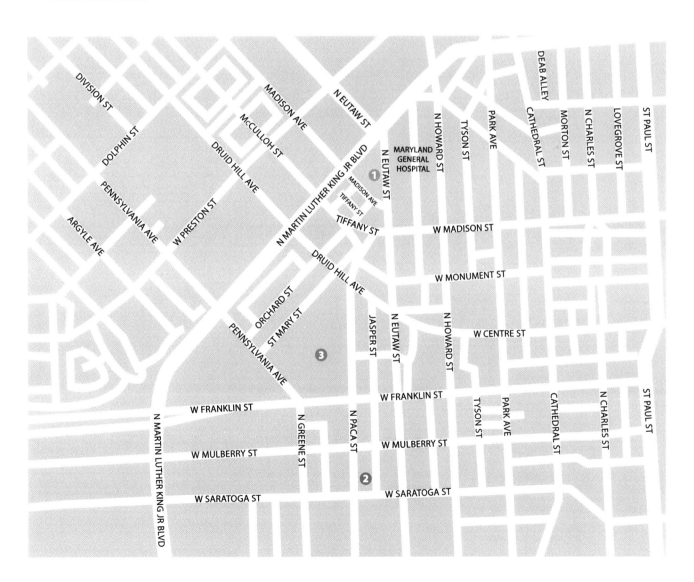

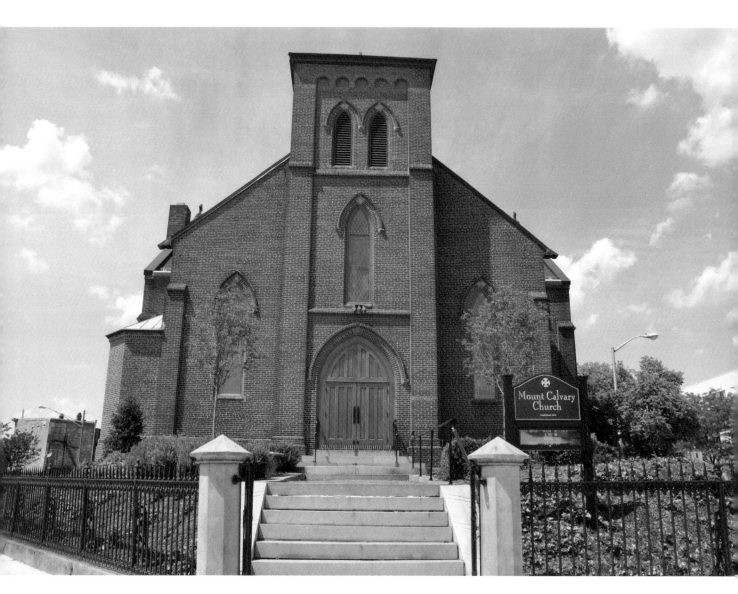

Mount Calvary, designed by Robert Cary Long Jr., stands on a wedge-shaped plot of land in Seton Hill

1846

Architect: Robert Cary Long Jr.

Newly restored to its former glory

Mount Calvary Church rises above the surrounding area on a wedge-shaped plot at Eutaw and Madison Streets. The congregation worships in the Anglo-Catholic tradition. The building has a simple brick exterior marked with Gothic windows and a central square tower on the front. A tall, wooden, white steeple originally graced the tower before it was toppled in a snowstorm in 1914 and never replaced. Gable roofs are on the east and west sides of the church, and a handsome iron fence surrounds the property.

In the 1840s, when Old St. Paul's Church became overcrowded, part of the congregation decided to build a new church on the outskirts of the city. The group hired Robert Cary Long Jr. to design the church, which was consecrated on February 19, 1846. The church has been enlarged twice since then. In 1853, a twenty-two-foot extension was added to the north end of the building, and the altar was moved from a side wall to the north end of the church. In 1885, the chancel was expanded again to its current size.

The most recent renovation in 2008 returned the interior of the church to its earlier beauty. All of the pews were removed so that the center and side aisles could be widened to allow for church processions, and new pews were installed. The new tile floors in the nave are rose colored with accents of blue and yellow. The walls in the nave are two tones of teal green with decorative stenciling around the arched stained glass windows. Faux marbleized wainscoting covers the heating units along the side

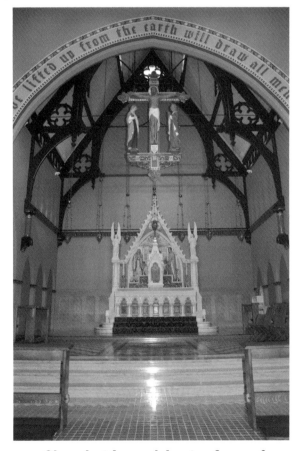

Chancel with a rood showing figures of Mary and Joseph on either side of Jesus.

walls, and exposed wooden trusses support the roof. Because the roof began to sag in the 1940s, wooden columns were installed for support.

Marble steps lead to the chancel, which has walls of a deep rose color. Inscribed on the central chancel arch are the words "If I be lifted up from the earth I will draw all men unto me." Hanging from the arch is a large, carved-oak polychrome rood, or cross, depicting the Crucifixion of Jesus along with statues of Mary and Joseph. Stenciling outlines the arch.

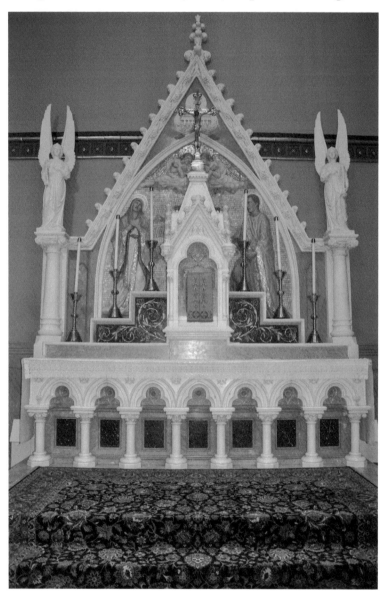

The twelve foot high altar of white marble is by John LaFarge. In the mosaic of Mary and Joseph, the trim of their garments shimmer with the mother of pearl.

The twelve-foot-high altar designed by John LaFarge is of white marble with a central peak accented with crockets. Angels on pedestals stand on each side. During the restoration, paint was removed from the altar, revealing the stunning beauty of a mosaic with figures of Mary and Joseph. The trims of their garments shimmer with mother-of-pearl. The tabernacle is a smaller version of the large altar. The altar to the left of the chancel features polychrome figures of Michael, Christ the King, and Gabriel. On the right of the chancel is the Altar of Sacrifice which contains a relic of Mother Seton who became the first American saint (see St. Mary's Chapel). A shrine of the Blessed Virgin Mary is on the west wall. Above the doors leading to the sacristy are figures of St. Elizabeth, St. Joseph, and John the Baptist. There are plaster Stations of the Cross along the side and rear walls of the nave. Confessionals on each corner of the rear of the church date from the 1860s.

In 1961, an Andover-Flentrop organ was installed. Built by Charles Fisk, it is modeled on earlier German organs with a tracker mechanical action. The organ is in the rear of the church in a balcony built to accommodate the console. The All Souls' Chapel is on the west wall of the narthex where daily services are held. A bronze tablet in the narthex indicates that Robert E. Lee was a member of the church when he lived in Baltimore while supervising the construction of Fort Carroll just down the river from Fort McHenry.

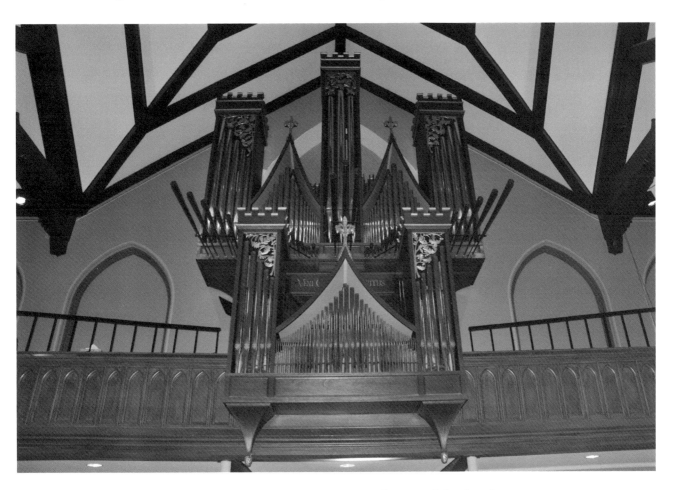

The Andover–Flentrop organ is in the rear of the church.

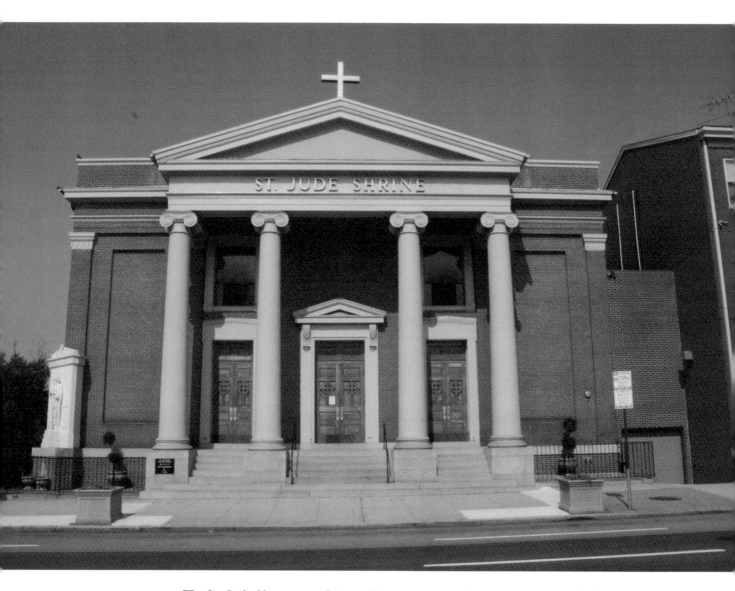

The St. Jude Shrine was designed by John Lewis Hayes and built in 1846 in the Greek Revival style. To the left is a statue of St. Jude.

1846
Architect: John Lewis Hayes

International center for devotion to St. Jude

St. Jude is the patron saint of desperate and hopeless cases. St. Jude Shrine provides a sanctuary for the Pallottine Fathers to offer numerous masses and novenas (a recitation of prayers for nine consecutive days or weeks for a specific purpose) for Catholic faithful from Baltimore and for visitors from all over the country. While today the handsome church has no congregation, it has been home to three different congregations from two different denominations since its construction in 1846.

The church was originally built as the Seventh Baptist Church in 1846, but the Baptists moved to a newly constructed church building at the corner of North Avenue and St. Paul Street after the Great Fire in 1904. A congregation of Lithuanian Catholics then moved into the building from its former church building on Lloyd Street (see Lloyd Street Synagogue) and renamed it St. John the Baptist Catholic Church. When the Lithuanian congregation moved to its present-day home at St. Alphonsus (see St. Alphonsus Church) on Park Avenue in 1917, Cardinal Gibbons transferred St. John the Baptist Catholic Church to the Pallottine Fathers, who served the booming Italian community in the neighborhood.

The Novenas to St. Jude were introduced during World War II, when the church was open twenty-four hours a day so that congregants and others could pray for the safety of servicemen. The popularity of the St. Jude novenas continued to grow even after the war ended. When the Italian population, which the church had served for many years, moved away from the neighborhood, the church was renamed St. Jude Shrine. Today, in addition to hosting visitors attending mass and novenas, the Pallottine Fathers offer prayers to St. Jude from the many requests received by mail, over the telephone, and via the Internet.

St. Jude Shrine, built in the Greek Revival style, is a brick rectangular building distinguished by its bold white portico. Four tall Ionic columns support a pediment roof, which has the shrine's name in gold letters on the frieze. A brick parapet mirrors the shape of the portico roof, is trimmed with white, and is topped by a gold-painted cross. Blue and green stained glass panels with a Celtic cross design are part of the massive oak central door and two flanking doors. The

central door has a white pediment that resembles the portico roof, and two large windows are above the side doors. An exterior marble statue of St. Jude produced by the Mullan-Harrison Company in 1967 is placed at the southeast corner of the building.

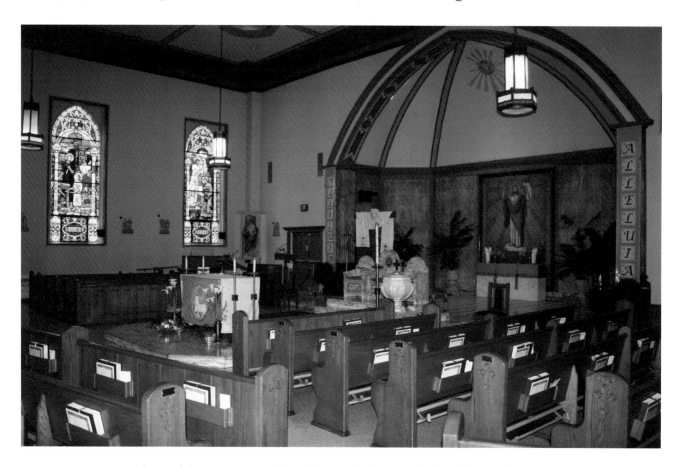

View of the sanctuary with a floor to ceiling mosaic of Christ in the apse.

In the small narthex is a bronze statue of St. Vincent Pallotti in front of a shimmering mosaic wall. On the opposite wall of the narthex is a contemporary mural in stained glass of the Holy Spirit by Stanley Ducek. In the sanctuary, pews have been positioned to accommodate a large Carrera marble platform, which holds a simple white marble altar table, baptismal font, lectern, and three marble chairs. The apse is a half dome on the wall behind the altar and features a floor-to-ceiling mosaic of Christ. His garments are highlighted by flecks of gold. In the arch of the dome is a representation of the Holy Spirit. Altars to Jesus and the Blessed Sacrament and the Altar to the Blessed Mary are on either side of the central altar.

Under the leadership of Rev. Father Graziani (1935–1941), the church was renovated. The side balconies were removed, leaving two rows of five windows on the south side of the church and two rows of three windows on the north side. Since this was not pleasing aesthetically, the solution was to raise the lower tier of windows to meet the upper tier of windows. The new stained glass windows, depicting biblical scenes, were designed by John Spagnola and produced in the Luther

The St. Jude Shrine is in a small room off the sanctuary. A statue of St. Jude stands before a shimmering wall of mosaics.

Studios of New Jersey. Each window is topped with a carved design of plumes and scrolls. The Italian names below the windows date from the time when this was an Italian parish. Gold-painted Stations of the Cross are placed between the windows. The balcony at the rear of the sanctuary has two stained glass windows depicting the Archangel Michael holding a sword and the Blessed Mary holding the infant Jesus. A flat, blue ceiling features painted stencil work, and a deep molding at the ceiling is painted in varying shades of blue. In an alcove at the rear of the church is a relief carving of Mary Queen of Apostles. The relief and mosaic work was done by Stanley Ducek.

The St. Jude Shrine is in a small room at the rear of the church. The name of the shrine is on a marble panel above the entrance. The shrine's interior has two mosaics depicting the Infant of Prague and Our Lady of Chains. A marble statue of St. Jude is in an alcove in the room, showing St. Jude clothed in gold garments and covered with a green marble cloak, and he stands before a predominately gold mosaic wall. There are banks of candles on two walls of the shrine. Because of the danger of fire in such a small room, the candles are now electric.

By redefining its purpose, the St. Jude Shrine has become a destination for pilgrims from Maryland and beyond and a dynamic center serving the needs of the Catholic faithful.

A mosaic of the Infant of Prague.

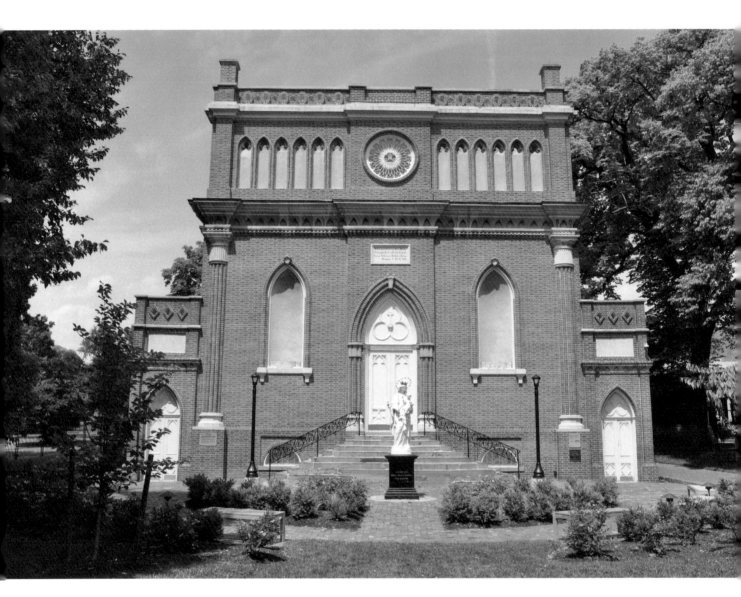

St. Mary's Chapel was designed in 1808 by Maximilian Godefroy in the neo-Gothic style to serve as a chapel to an adjacent seminary.

1808

Architect: Maximilian Godefroy

Where America's first saint took her vows

St. Mary's Seminary was established by the Sulpician Fathers in 1791 as the first Roman Catholic seminary in the United States. St. Mary's Chapel was built adjacent to the seminary to serve the seminarians and was dedicated by Archbishop John Carroll in 1808. The seminary buildings were demolished in 1975 when a new St. Mary's Seminary was built adjacent to the Cathedral of Mary Our Queen in north Baltimore.

Maximilian Godefroy, a French émigré and architect, designed the chapel for the seminary. Godefroy also designed Baltimore's Battle Monument and the First Unitarian Church. Legend has it that the red brick used for the chapel was originally intended for the Basilica. When a decision was made to use stone to build the Basilica instead of brick, the Sulpicians appealed to Charles Carroll of Carrollton to buy the surplus brick for their chapel. The wealthy Carroll agreed to their request. Carroll, in addition to being the wealthiest signer of the Declaration of Independence, was also the only Roman Catholic to sign the document and lived to be its last surviving signer.

St. Mary's Chapel is Baltimore's first church designed in the neo-Gothic style. The flat front elevation is topped by a false parapet supported from behind with flying buttresses, and there are six empty niches on each side of a rose window in the parapet. An arch surrounds the central entrance door, above which is a trefoil window. Two arched empty niches flank the door. Statues intended for the two large niches and for the twelve smaller ones in the parapet were found to be too costly and never installed. A plaque above the door is inscribed: "The Lord is in his Holy Temple; Let all the earth keep silence before Him." Major renovations made to the chapel by Robert Cary Long Jr. in the 1830s and 1840s included adding a center tower, which was removed in 1916.

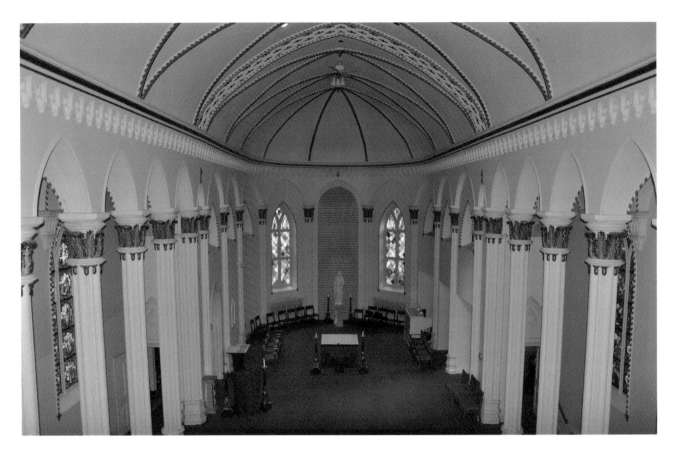

Slender Corinthian columns below the ribbed ceiling lead to the altar and the statue of Mary.

The interior is painted white. Five slender columns topped with gold-trimmed acanthus leaves run along each side aisle. Colorful stained glass windows on each side of the nave tell biblical stories. Quatrefoil designs decorate a small balcony at the rear of the chapel. Another round of major renovations to the interior were made in 1968 to conform to Vatican II measures. A simple wooden altar table was placed closer to the nave, and the original marble altar was removed to the lower chapel. Modern geometric windows of gray, gold, and pewter were installed in the apse.

The Lower Chapel. The statue to the left of the altar is Mother Elizabeth Lange, founder of the first black order of nuns, the Oblate Sisters of Providence and to the right, Mother Elizabeth Seton, the first American saint.

The Sulpician Fathers, who established the seminary, still manage the chapel as well as the Mother Seton House, which is on the same property. Elizabeth Seton, the first American-born saint, lived in the house for one year and took her first vows in 1809 in the chapel in the presence of Archbishop John Carroll. She founded the order of the Sisters of Charity in 1809 before moving to Emmitsburg, Maryland.

Sister Elizabeth Lange, a refugee from Haiti, settled in Baltimore in 1827. She and other black, French-speaking Haitian refugees worshipped at St. Mary's Chapel, where they were required to use the lower chapel for their services. At the time Lange professed her desire to become a nun, blacks were not allowed into any religious orders. With the support of the archbishop, she founded the Oblate Sisters of Providence, an all-black order, in 1829, at which time she took her first vows. The process for Sister Lange's canonization began in 1991. The "Chapel Bas," or lower chapel, features statues of Mother Lange and Mother Seton on either side of the altar.

A statue of Mary holding the infant Jesus with the chapel behind.

Francois Charles Nagot, S.S., founder of St. Mary's Seminary, is buried under the sanctuary. French-born archbishop Ambrose Maréchal, who served on the faculty at St. Mary's Seminary, is buried at the Basilica but he asked that his heart be left to St. Mary's Chapel where it is encased in the wall of the apse.

St. Mary's Chapel was listed as a National Historic Landmark on November 11, 1971.

① **Emmanuel Episcopal Church**
811 CATHEDRAL STREET

② **First and Franklin Street Presbyterian Church**
210 W. MADISON STREET

③ **Grace and St. Peter's Church**
707 PARK AVENUE

④ **Lovely Lane United Methodist Church**
2200 ST. PAUL STREET

⑤ **Mt. Vernon Place United Methodist Church**
10 E. MOUNT VERNON PLACE

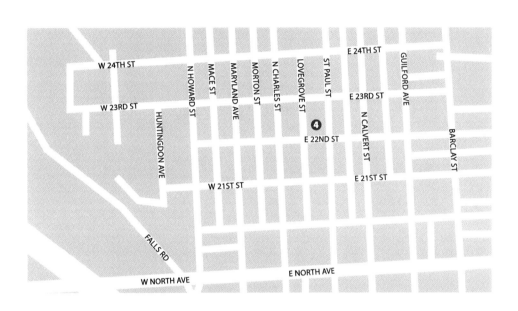

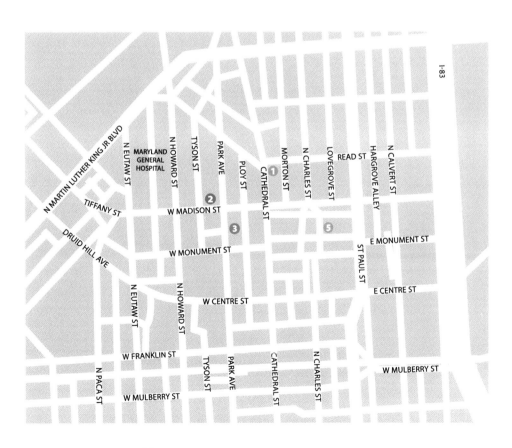

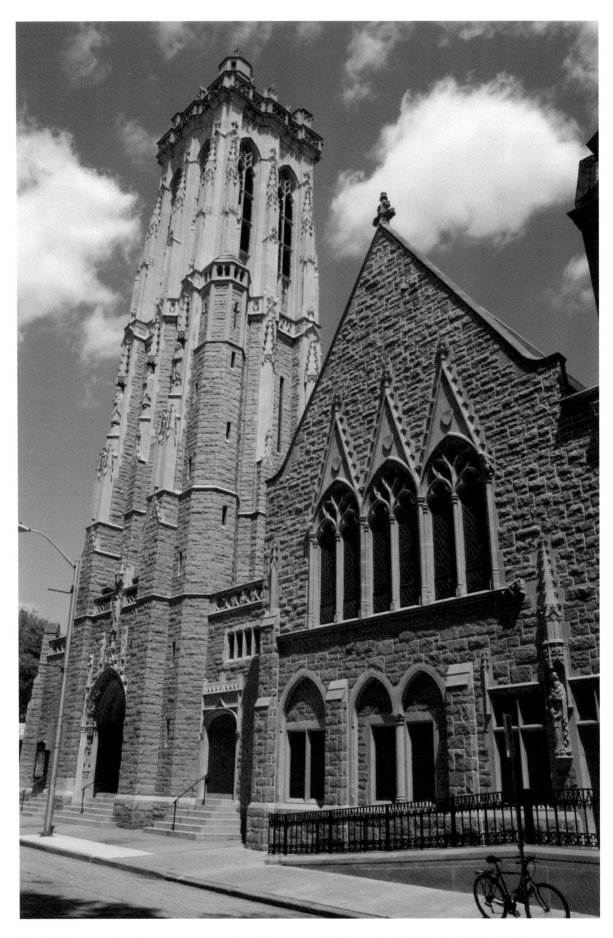

In 1920 a new facade was constructed on Emmanuel Episcopal which included the Christmas Tower.

1854
Architects: John Rudolph Niernsee and J. Crawford Nielson

The church with the Christmas tower

Emmanuel Episcopal Church grew out of antecedent churches in the St. Paul Parish, one of thirty parishes established in Maryland by the Church of England in 1632. The congregation's first church was a mission chapel established by the Old Christ Church in a building at Baltimore and Front Streets. However, the wealthy congregation wanted to establish itself in the new, exclusive area of Mount Vernon. Architects John Rudolph Niernsee and J. Crawford Nielson were engaged to design the church. The resulting building, a Gothic-style cathedral with a square Norman-style tower, opened in 1854. Over the subsequent years, modifications have added to the church's luster, making it a structure rich in the work of outstanding craftsmen and artists.

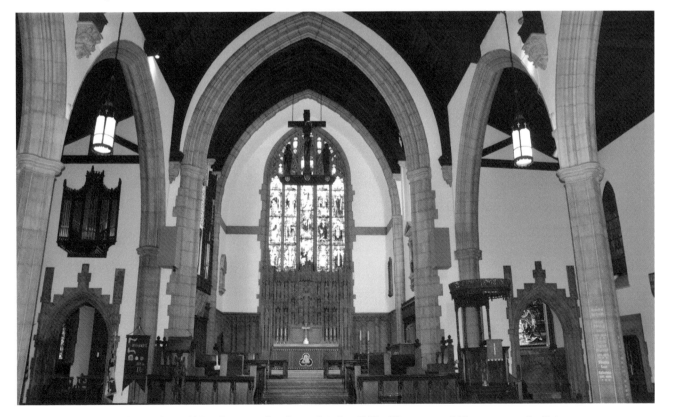

*The Great East Window in the chancel is by C.E. Kempe and Company. A glimpse
of the John LaFarge window in the baptistery can be seen on the right.*

The years 1919 and 1920 marked a time of renovations to Emmanuel. The original front façade of the church was replaced with light gray granite and limestone. One can observe the before-and-after effect by viewing the church from Read Street, where the original building and the new façade meet. In 1920, the original tower was replaced with a more ornate, 137-foot tower. The new tower, known as the Christmas Tower, was designed by Waldemar Ritter of Boston and carved by John Kirchmayer, the famed Oberammergau carver. On the tower are carvings depicting the three wise men, shepherds, and angels. Cherubic musicians playing an assortment of instruments, including violins, cymbals, and drums, are carved into the arch above the entrance. A sculpture of the Virgin Mary and child is on the corner of the building next to the parish house.

Entering the vestibule, murals on either side of the door depict the Crucifixion and the Visit of the Magi, painted by Evan Keehan. The focal point of the nave is the great east window, created by C. E. Kempe and Company of London. The window is within an arch surround. Done in the fifteenth-century style, recording the evolution of the Christian church, the window enhances the chancel with warm light. The altar of Tennessee marble was designed by Henry Vaughan, architect of the National Cathedral in Washington DC. The reredos (a carved screen placed behind the altar) was carved of Indiana limestone by Kirchmayer and features the Risen Savior flanked by figures from the Old and New Testaments. Included in the lower corner of the reredos is the likeness of Emmanuel's renowned preacher Hugh Birkhead (pastor, 1912–1929). A rood (a large crucifix) hangs above the chancel in memory of Dr. Birkhead.

The bas-relief on the south wall of the chancel is the likeness of Dr. James Houston Eccleston

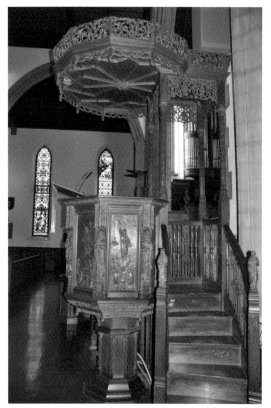

The pulpit carved by John Kirchmayer has a filigree canopy.

(pastor, 1884–1911) made from his death mask, and executed by Hans Schuler. The wooden pulpit with a filigree canopy, also carved by Kirchmayer, represents great preachers from Moses to John Wesley. Two small carved figures of Samuel and St. James adorn the newel posts of the pulpit steps.

In 1918, the balconies were removed and eight Gothic arches and columns were added to the nave. There are four Tiffany windows in the nave. Other windows were made by various English artisans. On the walls are painted shields depicting the twelve disciples and other Christian symbols. The pews of Flemish oak can seat six hundred people.

The Chapel of Peace, designed by Ritter and with carvings by Kirchmayer, is located to the north of the chancel. This chapel was dedicated on November 11, 1920, the second anniversary of the armistice of World War I. The altar here is of pink Tennessee marble. A solid oak triptych depicts Jesus at the Supper at

Emmaus; side panels show Jesus forgiving Peter and the appearance of the Risen Jesus to his mother. In this chapel is one of the few yellow-glass medallion windows done by C. E. Kempe and Company of London. The benefactor, Mrs. Louis C. Lehr, the great-granddaughter of Nelly Custis, requested that yellow flowers be placed in the window each Easter.

To the south of the chancel is the baptistery, glowing with light from three John LaFarge windows that are considered to be the best of his in the country. Daniel Chester French, sculptor of the figure of Lincoln in the Lincoln Memorial in Washington DC, carved the baptismal font. It is the only example of French's work in Baltimore. The font is the figure of a kneeling angel; French's daughter was the model for the figure. Bessie Wallis Warfield, who became Duchess of Windsor, was baptized at the font in 1896.

The Eccleston Chapel is in the lower level of the church. A sexton made a surprising discovery there of a fourth LaFarge window that had been covered over for years. General George C. Marshall married Kathryn Brown in this chapel with General John J. Pershing as his best man.

In 2008, a Letourneau organ was installed, replacing the Austin and Roosevelt organs.

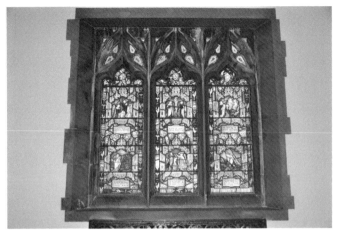

The great granddaughter of Nelly Custis commissioned this yellow glass medallion window in the Chapel of Peace.

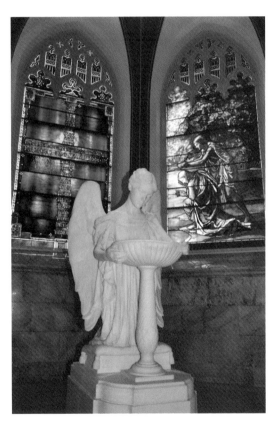

The baptismal font is by Daniel Chester French and stands before the LaFarge window depicting Jesus's baptism by John the Baptist.

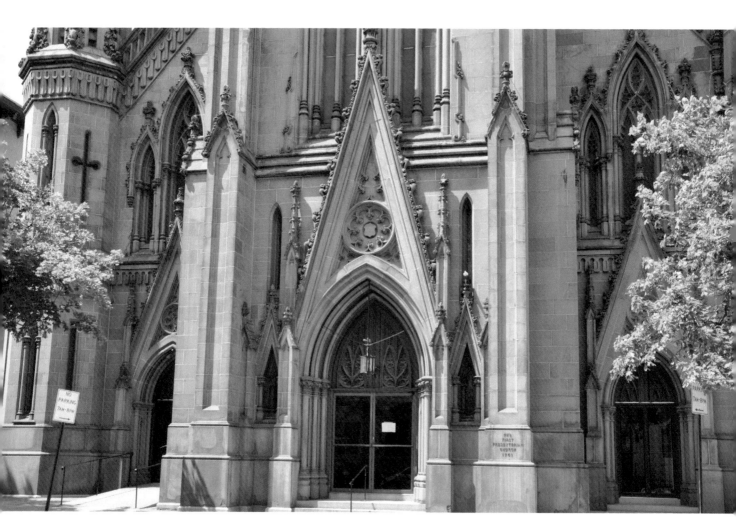

The entrance to First and Franklin has richly ornamented arches and peaks.

First and Franklin Street Presbyterian Church

210 W. Madison Street
Baltimore, MD 21201

1859
Architect: Norris G. Starkweather

The tallest church spire in Baltimore

First and Franklin Street Presbyterian Church is not located on First Street or Franklin Street, but the name memorializes First Presbyterian Church, Baltimore's oldest Presbyterian church, founded in 1761, and Franklin Street Presbyterian Church, founded in 1844 by Scots-Irish families. The two congregations joined in 1973 to form First and Franklin Street Presbyterian Church and meet in First Presbyterian's church building at the corner of Park and West Madison Streets in Baltimore's Mount Vernon neighborhood.

The 1859 church was designed by Norris G. Starkweather in the Victorian Gothic style. Starkweather later became the superintendent of government buildings in Washington DC. Built of New Brunswick freestone with a rich cocoa color, the most striking feature is the 275-foot spire, the tallest in Baltimore and visible in all directions from miles away. Despite its massive size and height, the many smaller, slender spires surrounding the tall steeple give the church the look of a delicate, finely chiseled structure.

Although the church was dedicated in 1859, it was not until 1874 that the spire was completed. Architect E. G. Lind collaborated with Starkweather in constructing the spire. Starkweather designed the building to carry the extreme weight of the tall steeple. Eight-feet-by-fourteen-feet solid stone piers were sunk eight feet into the earth. Resting on these piers are granite blocks and cast iron columns. The columns were a marvel of engineering at the time, described as "the most massive and scientifically arranged cast iron framework ever done in this country or any other." There are no bells in the steeple or elsewhere at First and Franklin.

The openness of the interior is possible because of the weight-bearing walls and the elaborate truss work in the attic. A soaring triple-vaulted ceiling of plaster on wood

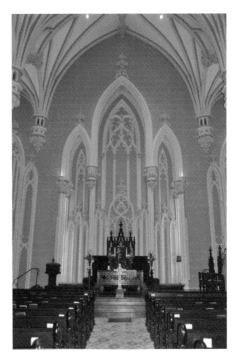

The vaulted ceiling, high arches, hanging pendants and dusty rose walls make a striking interior.

is accented by truncated pendants which still have the original gas jets. The dusty rose interior features an abundance of arches defining the windows, the chancel, the altar, and the organ loft. The pulpit and chancel chairs are of carved ebony and stand upon a newly expanded raised platform . The black walnut pews still display pew numbers. Balconies extend around three sides of the interior. Tall windows extend from the ceiling behind the balconies to the wainscoting below. Three of the west windows are by Tiffany Studios. On this side there is also an Italian stained glass window showing the image of the window donor's grandson, who died at an early age. The tissue-thin glass of the Italian windows is very luminous in contrast to the heavier Tiffany windows. In 1961, the Austin organ, framed by immense Corinthian columns in the rear balcony, replaced the earlier Roosevelt and E. M. Skinner organs.

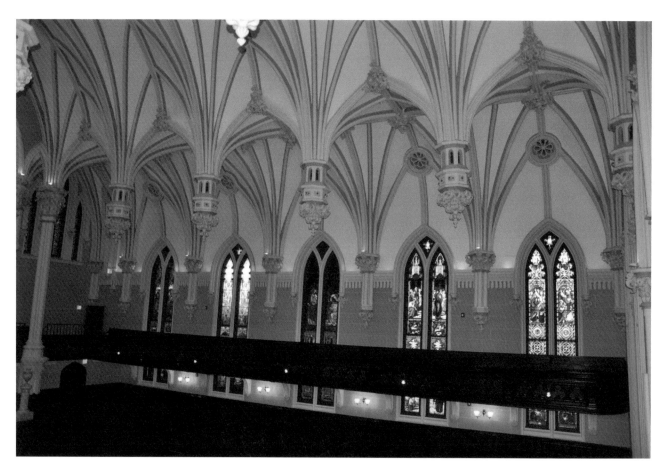

Side balconies partially obscure the tall stained glass windows.

In 1979, a crack six inches wide and six feet long was discovered in one of the steeple's major load-bearing wooden trusses in the attic of the sanctuary. For fear that the steeple would collapse, the church was closed for the next two and a half years while a steel superstructure was installed to support the steeple. Services were moved to the adjacent Reid Chapel, which had been converted from a lecture hall to a chapel by Boston architect Ralph Adams Cram in 1940. In 1980, a terrifying event occurred when sparks from a fire that started in a building several blocks away set fire to the chapel's roof. The intensity of the fire was described by Mrs.

Audrey Suhr, a member of the church who witnessed the fire: "Flames were shooting out of the chapel roof and smoke was pouring from the steeple.… There were firemen on ladders chopping holes in the chapel roof." The chapel roof collapsed, but the main church did not catch fire. Mrs. Suhr continued, "Incredibly just days before the fire the attic area had been cleaned. Two tons of dead pigeons and pigeon droppings and coal dust were removed from inside the roof. The Fire Chief said that if this had not been done, the Church would have exploded like a tinder box." The chapel was restored and boasts stained glass windows by Connick Studios of Boston, fine carved woodwork, and a small Moller organ.

The roll of early members of First Presbyterian reads like a who's who of Baltimore's most prominent citizens. Streets today bear the names of some of those early members: Gilmor, Stirling, Mosher, Sterrett, and Plowman. Early American patriots, such as General Samuel Smith, General John Stricker, Colonel James

The elaborate hanging pendant originally lit the interior with gas jets.

McHenry, and Colonel William Buchanan, were active members serving as trustees and deacons. The first mayor of Baltimore, James Calhoun, served as an elder. George Brown (whose widow built Brown Memorial Church in his memory) was a major donor for the construction of the church. Legendary beauty Elizabeth "Betsy" Patterson, who married Jerome Bonaparte, Napoleon's younger brother, was also a member.

A cherished artifact owned by the church is a walking stick given to the first pastor, Dr. Patrick Allison, by George Washington. Dr. Allison was a close friend of Washington and served as chaplain to the Continental Congress when it met in Baltimore in 1776. All the senior pastors' names are engraved on the walking stick.

The building was listed on the National Register of Historic Places on June 18, 1973.

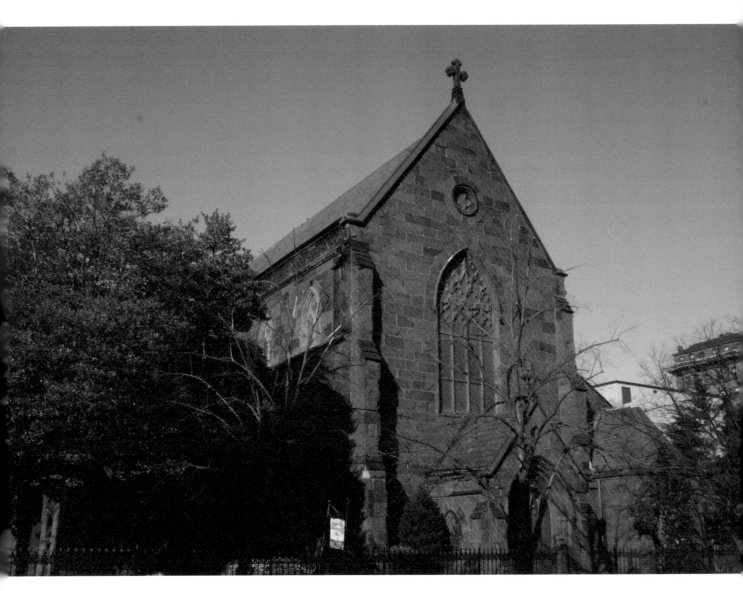

A stone cross accents the peak above the entrance of Grace and St. Peter's church.

Grace and St. Peter's Church
707 Park Avenue
Baltimore, MD 21201

1852

Architects: John Niernsee and James Neilson

The first brownstone church in Baltimore

Grace Church was founded in 1852 to serve members of the Anglo-Catholic faith in the surrounding wealthy Mount Vernon area. The affluent congregation could afford to build a church befitting its members' social positions. The brownstone exterior was designed to give the impression of a small, rural English church enhanced by a garden enclosed by a handsome iron fence. In 1912, Grace Church merged with St. Peter's Church. St. Peter's, the older of the two congregations, was founded in 1802 and located on Druid Hill Avenue. Today, St. Peter's former church is the home of Bethel AME Church (see Bethel AME Church).

The main entrance on Monument Street is reached through a recessed arched doorway under a gable roof. Above the entrance is a narrow arched window with tracery at the top. A small quatrefoil window is just beneath the main gable roof. Stone crosses accent the roof peaks. To the right of the entrance is an attached, one-story circular structure with a cone-shaped roof.

Buttresses accent the corners of the building as well as the spaces between the windows along the side of the church. A heavily decorated cornice runs beneath the roofline. There are two rows of windows along the side of the church—clerestory windows with quatrefoil tracery at the top with larger, similar windows below.

Despite the appearance of a small church on the outside, the interior is large, seating six hundred people. Terra cotta is the predominant color of the walls and of the Victorian-era Minton floor tiles imported from England. Interior columns support seven Gothic arches along the length of the nave. The high wooden interior ceiling is defined by trusses ending in truncated pendants. Pews are black walnut with finely carved high posts.

Within an enclosed area to the left of the entrance is a marble baptismal font of a kneeling angel holding a bowl. The

The baptismal font was carved by Albert Bertal Thorwaldsen.

designer, Danish sculptor Albert Bertal Thorwaldsen, also sculpted the large figure of Jesus that stands under the dome of Johns Hopkins Hospital.

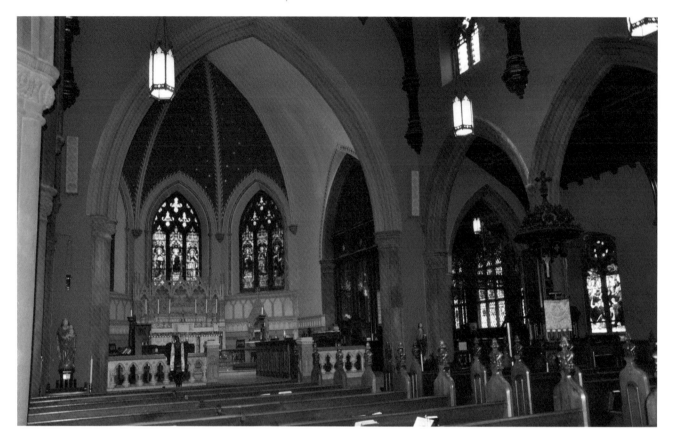

High backed pews line the aisle leading to the chancel. The stone altar
is beneath a brilliant blue ceiling dotted with stars.

A high stone altar designed by Henry M. Congdon is under the curved arch of the apse, which has a brilliant blue ceiling. Three stained glass windows light the altar area. The altar rail is of veined marble with a cap of pink marble and columns of variegated marble below. On the left side of the altar rail is a sixteenth-century statue of Our Lady of Grace. A statue of St. Peter, the church's patron, stands to the right of the altar rail. The screen, or reredos, behind the altar depicts Leonardo da Vinci's *Last Supper.* On the left wall of the chancel, wooden polychrome sculptures of the twelve apostles, each holding an object that identifies him, stand on pedestals. Above stands a figure of Jesus.

Above the door to the sacristy is a bas-relief of St. Cecilia. Stained glass windows represent such famous studios as Tiffany of New York, Hardman of London, and Mayer of Munich. Stations of the Cross designed by Robert Robbins of New York are of polychrome wood.

The Lady Chapel has a painting of the Blessed Mother Adoring her Child.

Francis Baldwin designed the Lady Chapel, dedicated to St. Mary and located to the right of the altar. The reredos in this chapel depicts Gabriel's Annunciation to Mary and also frames a painting of the *Blessed Mother Adoring her Child*. A late-nineteenth-century icon of St. Nicholas is on a wall to the left of the altar. The richly carved oak interior is bathed with light from a series of stained glass windows.

The Chapel of the Resurrection at the back of the nave contains a confessional and also houses a columbarium, a wall in which urns with ashes of the dead are stored. Standing near the entrance to the Resurrection Chapel is a statue of Charles Stuart, King and Martyr. The Austin Opus 1074 organ was installed in 1922.

An altar to King Charles with a Tiffany window and a station of the cross.

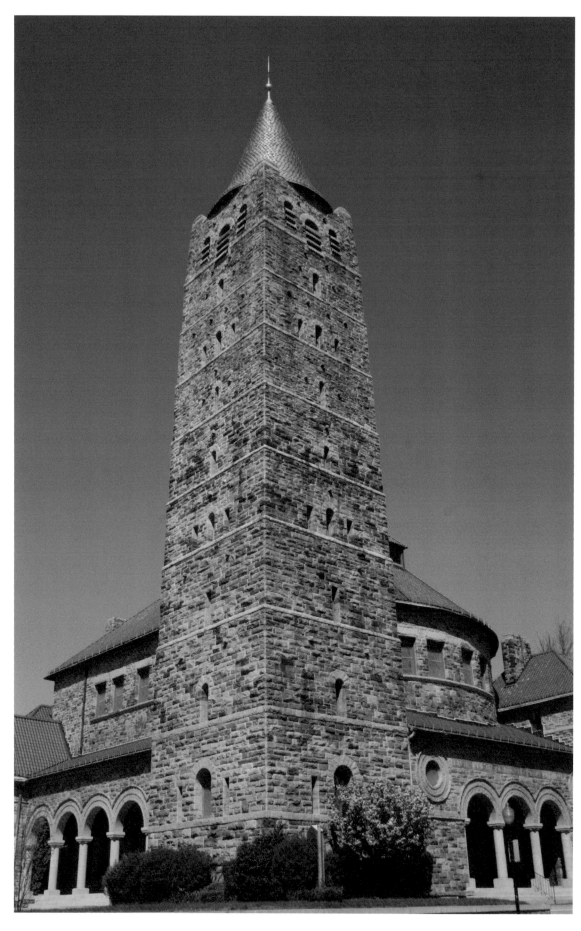

The elegant tower is fashioned after the bell tower of Santa Maria in Porto Fuori, Italy.

1887
Architect: Stanford White

Mother church of Methodism

Joseph Pilmore, an English Methodist missionary, founded the first Methodist Society in Baltimore Town in 1772. The congregation built a small chapel in 1774 on John Lovely's Lane. Ten years later, an independent Methodist Episcopal Church was organized in the chapel at the famous Christmas Conference. There, Francis Asbury, an English missionary who became a leader of the American Methodists, was ordained as a deacon, an elder, and a bishop on three consecutive days. The site of the original chapel is marked by a bronze plaque at 206 E. Redwood Street.

One hundred years later, the Board of Bishops decided to build a new church to commemorate the centennial anniversary of the Christmas Conference, naming it Lovely Lane for its first location. Designed by Stanford White, this structure is considered by the American Institute of Architects as one of the most significant buildings in the United States. Located near the outskirts of Baltimore City in 1887, today the church is halfway between downtown and the city's northern border with Baltimore County.

The Romanesque design incorporates elements from Italian churches. The rough-hewn gray granite for the massive structure came from Port Deposit, Maryland. There is an arched Romanesque colonnade along the front (east) and south side of the church. The west wall is semicircular in design. The building appears almost squat and completely grounded in contrast to the elegant 186-foot bell tower with its red-tiled conical roof. The tower, a copy of the bell tower or campanile of Santa Maria in Porto Fuori, Italy, rises above the church's high-pitched red-tiled roof. A row of clerestory windows appears below the roofline. The tower narrows slightly, with each tier separated by a course of white stone. The architect's plans called for a cross on the top of the tower, but the building committee thought it "too Roman"; loophole windows in the tower were arranged so when lighted at night, light streams through to form a cross.

The unique circular interior of the sanctuary is emphasized by the balconies surrounding the space. A sixty-five-feet high dome dominates the sanctuary. Painted in the dome is a replica of the heavens as they appeared at 3:00 A.M. on the day of the dedication, November 6, 1887. Dr. Simon Newcomb, the first professor of astronomy at Johns Hopkins University, was commissioned to chart the heavens.

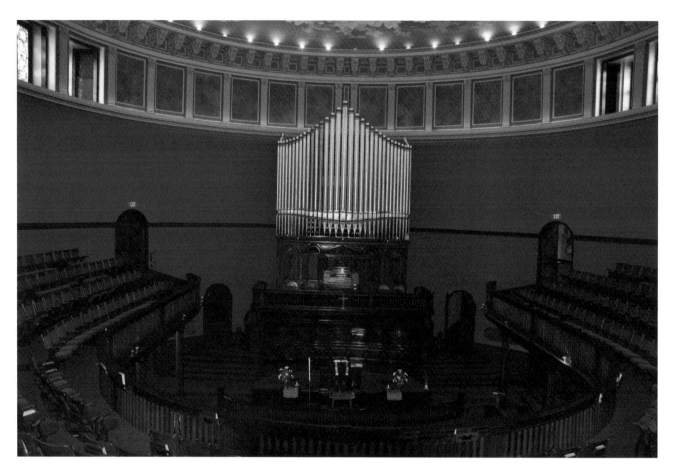

The pulpit, organ and choir loft as seen from the balcony.

In the dome, the Milky Way stretches across the heavens against a clouded blue sky sprinkled with 719 major stars and planets in their correct positions. Originally, a ring of fire, provided by 340 gas jets, within the rim surrounding the dome, illuminated the church without creating any shadows. Today the jets are replaced by hidden electric bulbs. Encircling the base of the dome are carved brackets of Corinthian design. A series of clerestory stained glass windows around the dome are a reproduction of the mosaics in the Ravenna Mausoleum in Galla Placidia, Italy. Between the windows are panels of marbleized rose, gold, and green colors.

The walls of the sanctuary are a deep rose color. Large stained glass windows in the sanctuary list the names of every pastor, beginning with Frances Asbury. Between these windows are plaques commemorating former pastors, including Dr. John F. Goucher, who spearheaded the building of Lovely Lane. He was also instrumental in founding Goucher College, originally built next to the church but now located in Baltimore County.

White designed all elements of this pulpit-centered church. The pulpit, choir loft, communion rail, and balconies are of highly polished dark wood. The black birch pulpit is a copy of one in the Church of San Apollinare in Ravenna. The case of the Roosevelt organ situated above and behind the pulpit has golden pipes trimmed in rose color to match the rose color of the sanctuary walls. Balustrades of closely spaced, short columns surround the balconies, the organ loft, and the communion rail. The balconies are supported by ten Ionic wooden columns.

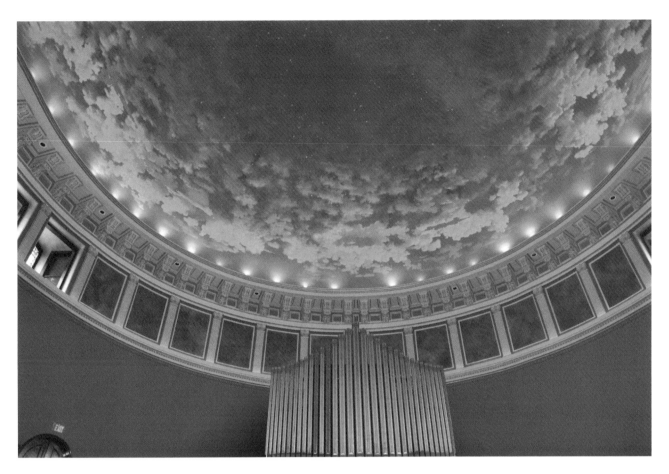

The dome is painted to replicate the heavens on the day the church was dedicated.

Rows of seats are arranged in a semi-circle facing the pulpit. No seat is more than 53 feet from the preacher. Each tilt-back seat is equipped with a hat rack beneath. A unique heating and cooling system allows for adjustment by opening or closing a grate under alternating seats. The church seats approximately 900.

Lovely Lane maintains a museum and archives. It contains records and treasures, including a portrait of Francis Asbury by Charles Peale Polk, hymnals, personal memorabilia, and the first pulpit ever used by a Methodist preacher in America. Among the valued items is Francis Asbury's Ordination Certificate.

Lovely Lane was listed on the National Register of Historic Places on May 25, 1973.

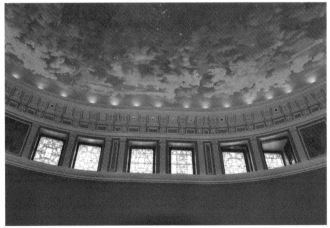

The stained glass design in the clerestory windows is inspired by Italian mosaics.

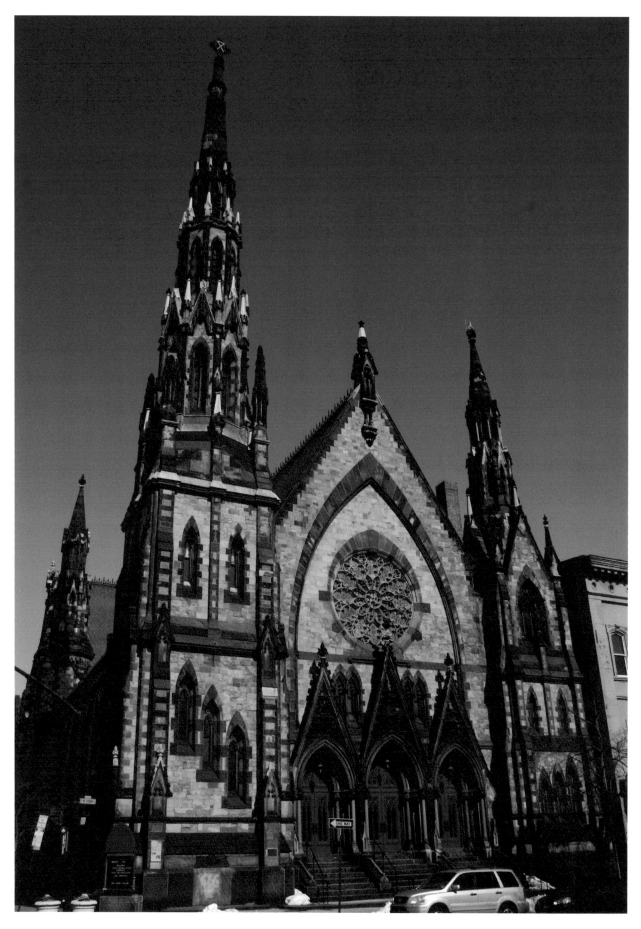

The architecturally imposing "Cathedral of Methodism" anchors a corner of Mt. Vernon Place.

1872

Architects: Thomas Dixon and Charles Carson

A cornerstone of Baltimore's most historic square

Mount Vernon Place United Methodist Church is a commanding structure located on the northeast corner of Baltimore's elegant residential Mt. Vernon Square. Centered in the square is the 178-foot Washington Monument, erected in 1814 as the first major monument to George Washington in the country. Mount Vernon Place United Methodist Church originated as the Charles Street Methodist Church at Charles and Fayette Streets. The pastor in 1870, Dr. Thomas Eddy, wished to move the church farther out to the more prestigious Mount Vernon Place and into a more architecturally imposing edifice. Dr. Eddy envisioned a "Cathedral of Methodism," which explains the grandness of the structure.

On the south façade of the church is a bronze plaque, designed by Hans Schuler. It reads, "Francis Scott Key, author of the Star Spangled Banner, departed this life on the site of this building January 11, 1843." Key's daughter lived in a mansion on the site with her husband, Charles Howard. It was in this house that Key died.

The most unusual aspect of the church is the green serpentine exterior. The rare stone, quarried from the Bare Hills quarry in Baltimore County, is no longer available. Red sandstone trim emphasizes the Gothic design elements of the building, including the pointed arches of the windows. Gray stone accents an abundance of spires on the exterior. Two large spires flank the front doors. The taller spire, a bell tower to the left of the entrance, soars to the sky encircled with three tiers of smaller spires. A third spire anchors the northwest corner of the church. Polished columns of granite flank the three entrance doors, and a pointed arch containing a small rose window tops each door. A large rose window, designed similarly to the one in the Notre Dame Cathedral in Paris, is centered in the large relieving arch above the front doors. The rose window over the side door is a smaller version of the south rose window. Right below the roofline on the west wall are grotesque faces said to be of prominent Baltimore persons living when the church was built. Along the spine of the roof is a row of decorative ironwork.

Bishop Francis Asbury, founder of Methodism in America, died in 1816 and was buried in a vault under the pulpit of the old Eutaw Methodist Church. When Eutaw Methodist Church merged with Mount Vernon Place Methodist Church in 1926, Bishop Asbury's remains were interred in Mount Olivet Cemetery. His burial plate is located in the narthex of Mount Vernon Place United Methodist Church.

Upon entering the sanctuary, the eye is drawn upward to the beamed ceiling. Wooden support trusses high above the nave are delicately carved. Below the clerestory windows, balconies surround the sanctuary. The church pews of American walnut can seat up to nine hundred people. Decorative carvings of vines and leaves on the ends of the pews were made by a local woodcarver over a period of seven years.

Francis Asbury's traveling pulpit.

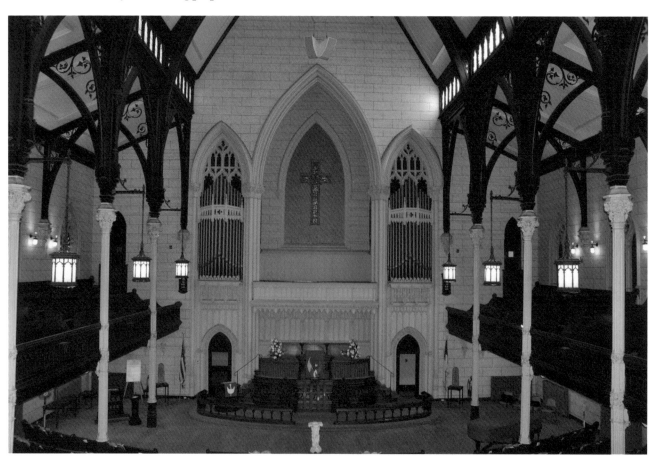

A ten foot stained glass cross by Connick Studios hangs above the pulpit.

A ten-foot stained glass cross, done by Connick Studios of Boston and installed in 1956, occupies the center arch behind the walnut pulpit. The deep, rich colors of the cross complement the six tall stained glass windows lining each side of the sanctuary. Asbury's small pulpit, from which he spoke on many occasions, is located to the left of the main pulpit. The rose window at the rear of the church is framed by the organ case. The Moller Organ Company built the 3,827-pipe organ.

The Sidney Stanton Bosley Memorial Chapel located behind the altar was built in 1947 in memory of Sidney Stanton Bosley, who was killed in a train accident at the age of twelve. Sidney was the son of the Rev. Harold A. Bosley. The eternal light in the chancel area burns constantly in his memory. The chapel window designed by David L. Connick depicts the young David and the young Jesus.

Mount Vernon United Methodist Church was listed on the National Register of Historic Places on September 17, 1971.

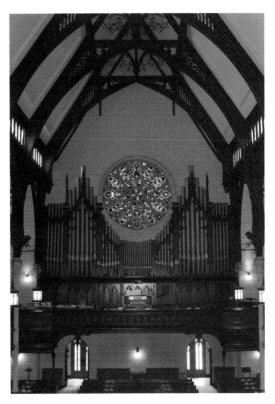

The large rose window is framed by the organ pipes. The ceiling's support trusses are decorated with delicate carvings of grape leaves.

GLOSSARY

Ambo – a stand from which the gospel is read

Apse – a projecting part of a church, often semicircular and vaulted, behind the altar

Baldachino – a decorative canopy over the altar, supported by columns

Baptistery – a portion of the church where the rite of baptism is performed

Baroque – a style marked by elaborate decoration combining architecture, sculpture, painting, and decorative arts

Barrel vault – a semicircular ceiling

Bas-relief – a low sculpture that projects slightly from a flat surface

Basilica – a church accorded certain ceremonial rights by the pope

Battlement – a parapet of alternating open and closed spaces, such as those seen on castles

Bema – also *bimah,* a platform from which services may be conducted

Bull's eye – a circular window

Buttress – a projecting structure used to support a wall, sometimes just for ornamentation

Campanile – a tall tower

Clerestory windows – windows at the upper part of the nave below the roof line

Chancel – the part of the church that contains the altar, pulpit, and lectern

Coffer – a decorated sunken panel in a ceiling, dome, or vault

Corinthian columns – a slender architectural column with ornate capital decorated with acanthus leaves

Cornice – a horizontal molded projection that crowns a building or wall

Cove – a concave surface at the transition of wall and ceiling

Crocket – ornamentation placed on the outer angles of pinnacles, spires, and gables

Cruciform – in the shape of a cross

Dentil molding – a series of small, closely spaced blocks forming a molding or projecting under a cornice

Doric columns– the simplest of the three Greek orders of architecture; columns have no base, shallow fluting, and simple capitals

Drapery glass – a method in stained glass that depicts folds

Dripstone – a projecting molding over windows and doors that deflects rain

Fenestrated – having windows or similar openings on the exterior of a building

Florentine – a style of art that flourished in Florentine renaissance, often characterized by inlaid mosaics

Fresco – a painting done on moist plaster

Gable – a triangular wall section at the ends of a pitched roof

Gothic style – an architectural style featuring pointed arches and ribbed vaults, glass, and a sense of height

Grotesque – a figure of whimsy and oddness

Hood molding – a raised projection over a window or door

Ionic columns – one of the Greek orders of architecture; distinguished by the scroll-like ornamentation on the columns' capitals

Italian Romanesque – heavy masonry construction with narrow openings, round arches, and barrel vaults

Loophole – a small, vertical, narrow opening in a wall

Lunette – a crescent-shaped opening

Medallion window – a circular window decorated with a figure or design

Mosaic – a picture or design formed by small inlaid pieces of enamel, glass, marble, or semiprecious stones

Monstrance – a glass-faced shrine in which the consecrated host is displayed

Narthex – a vestibule leading into the church

Nave – the central part of the church, extending to the chancel

Neo-Gothic – an architectural style resembling Gothic architecture, with pointed arches, high ceilings, ribbed vaults, and flying buttresses

Novena – a special nine days' devotion

Oculus – an opening at the center of a dome

Opaque – impervious to light

Palmette – a stylized leaf shape used as a decorative element in art and architecture

Parapet – a low wall that protects the edge of a roof

Palladian window – a large multi-paned window with a round top

Pediment – a triangular area resembling a gable at the end of a building or used as ornamentation over windows and doors

Pendant – a hanging ornament used in the vaults in Gothic architecture

Pilaster – an upright pillar projecting a short distance from a wall

Polychrome painting – using a variety of colors to paint an object

Portico – a kind of porch before the entrance, usually with columns

Quatrefoil – an opening or ornamentation showing four sections

Reredoes – an ornamental screen behind the altar

Romanesque – an architectural style that features rounded arches and vaults

Rood – a large crucifix placed at the entrance to the chancel

Rusticated surface– rough exterior

Sacristy – a room in which vestments and sacred vessels are kept

Sanctuary – the most sacred part of a religious building; where the altar is placed

Saucer dome – a concave circular ceiling

Spandrel – the triangular area between two adjoining arches

Tintinnabulum – a small, tinkling bell

Tracery – lacy ornamental work in a Gothic window with curves and intersecting lines

Transepts – the lateral arms of a cruciform church crossing the nave

Trefoil – an architectural form having the appearance of three leaves

Truncated pediments – shortened hanging ornaments

Truss – a framework of beams

Tympanum – the space between the arch and the upper part of a door or window, often decorated with sculpture

Vestibule – the entrance or narthex of the church

Victorian Gothic – an architectural style featuring ostentatious ornamentation, popular during the reign of Queen Victoria

Wainscot – the lower part of a wall usually finished differently than the rest of the wall

LIST OF ARTISANS
in Baltimore's Historic Houses of Worship

A

Anderson, Charles – plaster work at St. Ignatius

Andover-Flentrope Organ – Mount Calvary

Armstrong, Helen Maitland – Great East Window at Old St. Paul's Church

Austin Organ Company – First and Franklin, Emmanuel Episcopal, Grace and St. Peter's

B

Berge, Henry – replica of the Angel of Truth at First Unitarian Universalist Church

Brumidi, Constantine – paintings at St. Ignatius

Buichle, Lewis – silversmith, Communion vessels at Zion Lutheran Church

Burnaham, Wilbur – Chancel Window at Brown Memorial

C

Capellano, Antonio- Angel of Truth at First Unitarian Universalist Church
 friezes on the front of Old St. Paul's Church

Congdon, Henry – altar at Grace and St. Peters

Clayton and Bell – clerestory windows at Old St. Paul's Church
 angelic ministry windows in St. Peter's Chapel at Old St. Paul's

Connick Studios – windows in Reid Chapel at First and Franklin Presbyterian
 ten-foot cross at Mt. Vernon Methodist
 window in the chapel at Mt. Vernon Methodist
 some windows at Old St. Paul's Church

Costaggini, Fillipo – eleven apostles at St. Michaels (painting)

D

Ducek, Stanley – mural in St. Jude Shrine

E

Eckelston, Hans – sculptures at Zion

Everett, Bessie Yvonne Owens - mural at Bethel AME Church

F

Foertsch-Littau Art Glass Studio of Baltimore – stained-glass windows at Zion Lutheran

French, Daniel Chester – baptismal font at Emmanuel Episcopal

G

Godefroy, Maximilian – baptismal font at Old St. Paul's

H

Hardman, John – interior of Corpus Christi
 windows at Grace and St. Peter's

J

Jambor, Louis – mural titled *Glorification of St. Leo* at St. Leo's

K

Keehan, Evan – murals at Emmanuel Episcopal

Kempe Co. – yellow stained-glass window in the Chapel of Peace at Emmanuel Episcopal
 Great East Window at Emmanuel Episcopal

Kettler's of Munich – twelve stained-glass Palladian windows at St. Michael's

Kirchmayer, John – Christmas Tower at Emmanuel Episcopal
 reredos at Emmanuel Episcopal
 pulpit at Emmanuel Episcopal
 Chapel of Peace at Emmanuel Episcopal

L

LaFarge, John – windows at Emmanuel Episcopal, Altar at Mt. Calvary

Lamprecht, Wilhelm – ceiling painting of the Virgin Mary at St. Ignatius

Lehman, AA – tower at St. Michael's (added in 1889)

M

Mayer of Munich – some of the windows at Grace and St. Peter's

McShane Bell Foundry – bells of St. Leo, St. Vincent, St. Alphonsus and St. Michael

Mercer Tiles – decorative tiles on an exterior wall at Zion Lutheran

Minton Tile – Floor at St. Paul's

Moller Organ – Mt. Vernon Methodist, Old St. Paul's, St. Alphonsus, First and Franklin

Mullan and Harrison Company – exterior statue of St. Jude

N

Earl C. Nieman – completed Louis Jambor mural in St. Leo

Henry Niemann Organs – First Unitarian, Old Otterbein United Methodist

O

O'Dell Organ – Corpus Christi

R

Robbins, Robert – stations of the Cross at Grace and St. Peter's

Hilborne Roosevelt Organ – Lovely Lane, Old St. Paul's

S

Schuler, Hans – eagle at Zion Lutheran

 likeness of Eccleston at Emmanuel Episcopal

 Key plaque at Mt. Vernon Methodist

William B. Simmons Organ Co. – St. Ignatius

Skinner Organ – Brown Presbyterian Church, Old St. Paul's

Spagnola, John – stained-glass windows in St. Jude Shrine

Sudsberg, John – statue of St. Michael at St. Michael

T

Thorwaldson, Albert Bertal – baptismal font at Grace and St. Peter's

Tiffany Studios – windows at:

 Brown Memorial

 Emmanuel Episcopal

 First and Franklin

 First Unitarian and Universalist Church

 Grace and St. Peter's

 Lovely Lane Methodist Church – in the chapel

 Old St. Paul's Church

 windows, reredos glass mosaic

V

Vaughan, Henry – altar at Emmanuel Episcopal

W

Willet of Philadelphia – stained-glass windows for the 1890 remodeling of St. Vincent's (windows no longer there)

LIST OF ARCHITECTS

Francis Baldwin
 St. Leo the Great Roman Catholic Church
Charles Carson
 Berea Temple of the Seventh Day Adventists
Thomas Dixon and Charles Carson
 Mt. Vernon Place United Methodist Church
John B. Gildea
 St. Vincent de Paul Church
Maximilian Godefroy
 First Unitarian Church
 St. Mary's Chapel
John Lewis Hayes
 St. Jude Shrine
N. H. Hutton and John Murdoch
 Bethel African Methodist Episcopal Church
 Brown Memorial Presbyterian Church
Patrick Charles Keeley
 Corpus Christi-Jenkins Memorial Church
Benjamin Latrobe
 Basilica of the National Shrine of the Assumption of the Blessed Virgin Mary
Louis Long
 St. Michael the Archangel Church
 St. Ignatius Roman Catholic Church
Robert Cary Long Jr.
 Lloyd Street Synagogue
 Mt. Calvary Church
 St. Alphonsus Church
John R. Niernsee and J. Crawford Nielson
 Emmanuel Episcopal Church
 Grace and St. Peter's Church

George Rohrbach and Johann Mackenheimer
 Zion Lutheran Church
Jacob Small
 Old Otterbein United Methodist Church
N. G. Starkweather
 First and Franklin Street Presbyterian Church
Richard Upjohn
 Old St. Paul's Episcopal Church
Stanford White
 Lovely Lane United Methodist Church

BIBLIOGRAPHY

Blumenson, John J. G. *Identifying American Architecture*. New York: W.W. Norton & Co., 1977.

Brugger, Robert J. *Maryland A Middle Temperament*. Baltimore: The Johns Hopkins University Press in association with the Maryland Historical Society, 1988.

Caravan, Jill. *American Country Churches*. New York: Todtri Publications, ltd., 1996.

Chapelle, Suzanne Ellery Greene. *Baltimore, An Illustrated History*. Sun Valley, California: American Historical Press, 2001.

Chiat, Marilyn. *America's Religious Architecture*. New York: John Wiley & Sons, 1977

Ching, Francis D. K. *A Visual Dictionary of Architecture*. New York: Van Nostrand Reinhold, 1995.

Dorsey, John, and Dilts, James D. *A Guide to Baltimore Architecture*. Centreville, MD: Tidewater Publishers, 1997.

Durkin, Marie-Cabrini. *America's First Cathedral*. Strasbourg Cedex 2 France: Editions du Signe, 2007.

Durkin, Marie-Cabrini, *The Baltimore Basilica America's First Cathedral*. Strasbourg Cedex 2 France: Editions du Signe, 2006.

Hayward, Mary Ellen, and Shivers, Frank R. Jr., editors. *The Architecture of Baltimore*. Baltimore: The Johns Hopkins University Press, 2004.

Hyde, Susan, and Bird, Michael. *Hallowed Timbers*. Toronto: Stoddart Publishing Co., 1995.

Klein, Marilyn, and Fogle, David. *Clues to American Architecture*. Washington: Starrhill Press, 1985.

Lane, George, and Kezys, Algimantas. *Chicago Churches and Synagogues*. Chicago: Loyola University Press, 1981.

Nesmith, Eleanor Lynn. *Instant Architecture*. New York: Ballantine Books, 1995. Penner,Bernard, *Zion in Baltimore 1755-1955 History Book Supplement 1955-2005*. Baltimore, MD: Zion Church of the City of Baltimore, 2008.

Rifkind, Carole. *A Field Guide to American Architecture*. New York: New American Library, 1980.

Roth, Leland M. *Understanding Architecture*. New York: Harper Collins, 1993.

Spalding, Thomas W. *The Premier See, A History of the Archdiocese of Baltimore, 1789-1994*. Baltimore: The Johns Hopkins University Press, 1995.

Spaulding, Thomas, Kuranda,Katherine. *St. Vincent de Paul of Baltimore*. Baltimore, MD: The Maryland Historical Society, 1995.

Wilkinson, Philip. *Buildings*. New York: Doring Kindersley, 1995.

Wind, James P. *Places of Worship*. Nashville: American Association for State and Local History, 1990.

Yarwood, Doreen. *Encyclopaedia of Architecture*. London, B.T. Batsford Ltd, 1985.

Chapter 1—Bolton Hill/West Baltimore

Baltimore Sun "A New Departure in Ecclesiastical Architecture.", May 20, 1890

Bethel AME Church. *History of the Bethel AME Church*. Baltimore, MD: Bethel AME Church.

"Farewell Services Held," *Baltimore Sun*, November 5,1951.

Joan S. Feldman *Sacred Glass: The Tiffany Windows of Brown Memorial Park Avenue Presbyterian Church*, (Baltimore, MD: Brown Memorial Church).

Dr. Pat Fosarelli, *Corpus Christi Church 125 Years of Service*, (Baltimore, MD: Corpus Christi Church, 2005)

Ruth Greenberg, 1976. *The chronicle of Baltimore Hebrew Congregation 1830-1975*. Baltimore: The Baltimore Hebrew Congregation.

Rabbi Adolph Guttmacher, PhD, 1905. *History of the Baltimore Hebrew Congregation*. Baltimore: The Lord Baltimore Press.

Elmer P. Martin and Dr. Joanne M. Martin, "Daniel Coker, community leader." *Baltimore Sun*, February 19,1998." *Baltimore Sun*.

Frances S. Meginnis, *Requiescat In Pace, A History of the Corpus Christi-Jenkins Memorial Church*. Baltimore, MD: Corpus Christi, 1953.

L. Irving Pollit. 1945. *A History of Brown Memorial Presbyterian Church 1870-1945*. Baltimore, MD: Thomsen-Ellis-Hutton Co.

Rev. James Schuman. *Brown Memorial Park Avenue, The Stained Glass Windows*. Baltimore, MD: Brown Memorial Church.

Rev. James E Schuman. *Brown Memorial Park Avenue Presbyterian Church, USA, Carved Symbols in the Chancel, Stained Glass Windows*. Baltimore, MD: Brown Memorial Church.

Jane Tinsley Swope. *A History of Brown Memorial Presbyterian Church 1870-1995*. Baltimore, MD: Brown Memorial Church, 1995.

Chapter 2—Downtown

Archdiocese of Baltimore. *Basilica of the Assumption of the Blessed Virgin Mary.* Baltimore, MD: Archdiocese of Baltimore, 1994.

Matthew Hay Brown, "Two angels return to grace." *Baltimore Sun,* 28 April 2006, page 1A.

The Rev. Cornelius M. Cuyler, S. S. *The Baltimore Co-Cathedral Basilica of the Assumption of the Blessed Virgin Mary Its History and Description.* Baltimore, MD: Archdiocese of Baltimore, 1951.

Janice D'Arcy, "An Easter celebration, and then an unveiling." *Baltimore Sun,* Sunday, 27 March 2005, page 8A.

Stephanie Desmon, "Providence and peanuts.," *Baltimore Sun,* 19 April 2005.

Mathew Dolan, "With reopening of Basilica near; its message is alive," *Baltimore Sun,* Thursday, 16 March 2006.

Dan Fesperman, "Church stands up to two centuries of change" *Baltimore Sun,* 29 August 1996.

First Unitarian Church, *Welcome to the First Unitarian Church of Baltimore,* Baltimore, MD: First Unitarian Church, 1983.

Edward Gunts, "Basilica's history wins out over purity of design" *Baltimore Sun,* 16 October 2005.

Edward Gunts, "Most Beautiful Church in U.S." *Baltimore Sun,* Wednesday, 4 October 1995, page 5F.

Charles R. Hazard. *Basilica of the National Shrine of the Assumption of the Blessed Virgin Mary.* Baltimore, MD: 1993.

Jacques Kelly, "3 centuries of art in holy repository" *Baltimore Sun,* 27 March 1997.

J. William Joynes, *History of Old Otterbein United Methodist Church.* Baltimore, MD: Old Otterbein United Methodist Church.

Jessica Novak, "Otterbein's impact rings true" *Examiner,* 7 April 2007.

Old Otterbein Church. *"History of Old Otterbein United Methodist Church,."* (www.oldotterbeinumc.org/History of OOUMC.html).

Dennis O'Brien,. "Basilica to ring in robust voice, better timing" *Baltimore Sun,* Sunday 7 August 2006.

The Rev. Norman O'Neal, S. J. *The Life of St. Ignatius of Loyola.* Baltimore, MD.

Old Saint Paul's Church. *Self-Guided Tour.* Baltimore, MD: Old Saint Paul's Church.

Old St. Paul's Church. *Some Information about Old Saint Paul's Church.* Baltimore, MD: Old St. Paul's Church.

Father Casimir Pugevicius. "A Colorful History." *The Catholic Review*, Wednesday, March 8, 1995.

John Rivera, "Renovated dome to let light shine in" *Baltimore Sun*, Tuesday 20 November 2001, page 2B.

John Rivera, "St. Ignatius shines again in all its glory" *Baltimore Sun*, 11 December 1999.

Frank Somerville, "St. Alphonsus Marks 150 Years." *The Baltimore Sun*, Monday, 13 March 1995.

St. Alphonsus Church. *St. Alphonsus Lithuanian Parish Celebrates 100 Years of Service to God and Country*. Baltimore, MD: St. Alphonsus Church.

St. Alphonsus Church. *Where Saints Have Prayed*. Baltimore, MD: St. Alphonsus Church.

Klaus G. Wust,. *Zion in Baltimore 1755-1955*. Baltimore, MD: Zion Church of the City of Baltimore, 1955.

Zion Church of Baltimore. "Zion Church History." www.zionbaltimore.org/vthistory.

Chapter 3—Historic Jonestown/Little Italy/Fells Point

James Bock. "A parish in peril: Latinos seek to save St. Michael" *Baltimore Sun*, Sunday 25, December, 1994.

Louis F. Cahn, *The Jewish Historical Society of Maryland and the Restoration of the Lloyd Street Synagogue*. Baltimore, MD: The Jewish Historical Society of Maryland, Inc., 1981.

James Drew, "A tribute to a patron saint"*Baltimore Sun*, Monday, 18 August 2008.

Laura Greenback, "St. Leo's celebrates 125th anniversary, " *Examiner*, Monday, 2 October 2006.

The Jewish Historical Society of MD, *Opening Windows on the Past*, (Baltimore, MD: The Jewish Historical Society of MD).

Jessica Novak, "Maryland's Oldest synagogue bolsters Jonestown" *Examiner*, 3 February 2007.

Jessica Novak, "Jewish group's exodus built Baltimore's oldest active synagogue" *Examiner*, 10 March, 2007.

Jewish Historical Society of Maryland. *Historic Buildings*. www. JHSM.org.

Dan Rodricks, "Crane elevates a statue and spirits of Little Italy" *Baltimore Sun*, 14 January 2000.

St. Leo the Great Roman Catholic Church. *Historical Sketch of St. Leo's Parish*. Baltimore, MD: St. Leo the Great Roman Catholic Church, 1922.

St. Leo the Great Roman Catholic Church. *The Church of St. Leo the Great 1881-1981, the Heart of Little Italy*. Baltimore, MD: The Church of St. Leo the Great Press, 1981.

St. Michael the Archangel Church. *Visitor's Guide*. Baltimore, MD: St. Michael the Archangel Church, 1995.

St. Vincent de Paul Church. *History*. www.stvchurch.org/history.

Israel Tabak, "The Lloyd Street Synagogue of Baltimore: A National Shrine." New York, New York: *American Jewish Historical Quarterly*.

M. Dion Thompson, "Steeple's Return to Glory." *Baltimore Sun*, 27 November 2001.

Chapter 4—Seton Hill

Kelly Brewington. "Marking 200 years of faith." *Baltimore Sun*, Monday, June 16, 2008.

Joseph I. Dirvin, C. M. *Saint Elizabeth Ann Seton*. New York: Farrar, Straus and Giroux, 1962.

Historical Sketch of St. John the Baptist Parish Vertical files of Pratt Library.

Jacques Kelly, Revitalizing a church and its congregation," *Baltimore Sun*, Friday 17 October, 2008.

Jacques Kelly, "Seton Hill offers a glimpse into Baltimore's early days." *Baltimore Sun*, 15 August, 2009.

Mount Calvary Church. *Mount Calvary Church*. Baltimore, MD: Mount Calvary Church.

Mount Calvary Church, *Mount Calvary Church*. www.mountcalvary.com.

Mother Seton House. *The Mother Seton House*. Baltimore, MD: 1994.

Mother Seton House. *St. Mary's Chapel*. www.mothersetonhouse.org.

St. Jude Shrine. *St. Jude Shrine*. Baltimore, MD.

St. Jude Shrine. *St. Jude Shrine Nationwide Center of St. Jude Devotions*. Baltimore, MD.

Chapter 5—Mt. Vernon/Charles Village

Carl Bessent. *Emmanuel Day The time of change and Beautification*. Baltimore, MD: Emmanuel Episcopal Church, 1994

Emmanuel Episcopal Church,. *A Walking Tour of Emmanuel Church*. Baltimore, MD: Emmanuel Episcopal Church.

Emmanuel Episcopal Church . *Emmanuel Episcopal Church*. Baltimore, MD: Emmanuel Episcopal Church.

Emmanuel Church. The Christmas Shields. Baltimore, MD: Emmanuel Episcopal Church.

Edward Gunts. "A Divine Inspiration" *Baltimore Sun*, 14 July 2003.

Edward Gunts. "Heavenly Day." *Baltimore Sun*, 11 December 2003.

John Gardner. 1962. *The First Presbyterian Church of Baltimore A Two-Century Chronicle*. Baltimore, MD: First Presbyterian Church.

Marilyn McCraven, "City church is 'here to be used'" *Baltimore Sun*, 16 October 1996.

Fr. Donald L. Garfield, *A walking tour of Grace and St. Peter's Church*. Baltimore, MD: Grace and St. Peter's Church.

Grace and St. Peter's Church. *Grace and St. Peter's Church*. Baltimore, MD: Grace and St. Peter's Church.

Grace and St. Peter's Church. *Grace and St. Peter's Tour*. www.graceandstpeter.org.

Jacques Kelly, "3 centuries of art in holy repository" *Baltimore Sun*, 27 March 1997.

Lovely Lane United Methodist Church. *The Centennial Monument and Mother Church of American Methodism Bicentennial General Conference*. Baltimore, MD: Lovely Lane United Methodist Church, 1994.

Lovely Lane United Methodist Church. *To Restore and to Preserve*. Baltimore, MD: Lovely Lane United Methodist Church.

Mount Vernon Place United Methodist Church. *Mount Vernon Place United Methodist Church*. Baltimore, MD: Mount Vernon Place United Methodist Church.

John Rivera, "Icy collapse and renewal.'" *Baltimore Sun*, 2 October 1998.

John Rivera, "Plaster falls, but not spirit" *Baltimore Sun*, 18 September 2000.

Carl Schoettler, "Great playing in great places" *Baltimore Sun*, 3 December 1997.

Tanika White, "Restoring a divine vision" *Baltimore Sun*, Monday, 15 December 2003.

ABOUT THE AUTHORS:

Lois Zanow is a tour guide who gives tours of Baltimore, Washington, D.C. and Annapolis as well as tours further afield. She grew up in South Dakota, got her degree in history at the University of Minnesota and worked at the University of Wisconsin before moving to Chicago. In Chicago she gave tours of the city. Lois and her family moved to Baltimore where she worked for the Baltimore City Life Museums and continued her tour business.

Sally Johnston grew up in Maine and majored in history at Chatham College. After receiving her Masters Degree at the University of Pittsburgh she taught in Pittsburgh before moving to Baltimore. Sally and her family have lived in Baltimore for over 25 years. She was director of the Flag House and has worked at many of Baltimore's historic sites.

ABOUT THE PHOTOGRAPHER

Photographer Denny Lynch has been exhibiting his work in New York, Paris and many parts of Ireland since the 1990's. Much of his work has focused on Irish history and culture. His photographs have become part of the permanent collections of the Museum of the City of New York and the New York Historical Society.

CPSIA information can be obtained
at www.ICGtesting.com
Printed in the USA
275703LV00003B